THE INFINITE WORLD OF M. C. ESCHER

The Infinite World of M.C. Escher

M.C. ESCHER

J.L. LOCHER

Abradale Press/Harry N. Abrams, Inc.
New York

Edited by J. L. Locher

Library of Congress Cataloging in Publication Data
Escher, M. C. (Maurits Cornelis), 1898–1972.
 The infinite world of M. C. Escher.
 1. Escher, M. C. (Maurits Cornelis), 1898–1972.
I. Locher, J. L. II. Title.
NE670.E75A4 1984 769.92'4 83-22387
ISBN 0-8109-8059-2

This 1984 edition is published by Harry N. Abrams, Inc., New York.
It is a concise edition of Abrams' *The World of M.C. Escher,*
originally published in 1972, and was published by Abrams in
a paperback edition, distributed by New American Library, in 1974.
Copyright © 1971 in The Netherlands by Meulenhoff International,
Amsterdam. All rights reserved. No part of the contents of
this book may be reproduced without the written permission of
the publishers

Printed and bound in Japan

The Work of M. C. Escher

J. L. Locher

Maurits Cornelis Escher was born on June 17, 1898, in Leeuwarden, the capital of the province of Friesland in the northern part of the Netherlands. He spent most of his youth in the city of Arnhem, where he attended secondary school. It was evident even then that he liked to draw, and the drawing teacher at his school, F. W. van der Haagen, encouraged him and instructed young Escher in making some prints, most of them linoleum cuts.

After secondary school, on his father's advice, Escher went to Haarlem to study architecture at the now defunct School for Architectural and Decorative Arts. One of the faculty members there was the Dutch artist Samuel Jessurun de Mesquita, who discerned Escher's talent for the graphic arts and advised him to drop architecture. Escher, who had already found that architecture was not to his taste, took this advice gladly and pursued his education in the graphic mediums under Jessurun de Mesquita from 1919 to 1922.

After finishing his studies, Escher traveled frequently, mainly in Italy. In the spring of 1922, he went directly to Italy, and in the autumn of the same year he made a trip to Spain. From there he returned to Italy, which had begun to fascinate him so greatly that he moved to Rome, where he lived from 1923 to 1935. While living in Rome, Escher made long journeys through the Italian countryside every spring. During these trips, on which he often covered long distances by foot, he explored southern Italy, not popular for travel at that time and far from accessible. His destinations during the earlier years are difficult to trace, but we know that in 1926 he was in the vicinity of Viterbo; in 1927, in the northern part of the Abruzzi; in 1928, on the island of Corsica; in 1929, in the southern part of the Abruzzi; in 1930, in the little-known towns of Calabria; in 1931, on the coast of Amalfi; in 1932, first in Cargano and later in the vicinity of Mt. Etna and northeastern Sicily; in 1933, again in Corsica; in 1934, again on the coast of Amalfi; and in 1935, again in Sicily. On these journeys, he made drawings of whatever interested him, working out the best of them for prints during the winter.

The rise of fascism in the thirties made life in Rome less and less bearable for him, and he therefore moved in July, 1935, to Château d'Oex in Switzerland. From May to the end of June in 1936 he made what was to be the last of his long study trips, this time by ocean freighter along the coast of Italy to Spain. On this trip he made detailed copies of the Moorish mosaics in the Alhambra and in the mosque, La Mezquita, at Córdoba. In 1937 he moved to Ukkel, near Brussels, and from there he returned in 1941 to the Netherlands to settle in Baarn. In 1970 he moved to Laren. He died on March 27, 1972.

After 1937 Escher became less mobile. He traveled only as a form of vacation, to visit his children who live abroad, or on rare occasions in response to an invitation to lecture on his own work. In 1960, for instance, he visited England, Canada, and the United States to give lectures. But his trips no longer had importance for his work. His prints now originated—from the first studies to the final result—in his studio. Corresponding to the change in his way of living, there was also a change in his work after 1937. The direct impulse to make a print now almost always came not from observations of the world around him but from inventions of his own imagination—what we may call his visual thinking. This

change is so distinctly observable that we can divide his work into two groups: the work done before 1937 and the work done after 1937.

The first group, done before 1937, is dominated by the representation of visible reality—the Italian landscape and the architecture of the Italian cities and towns. In innumerable prints landscape and architecture are represented exactly and realistically. This realism demonstrates a vivid and, at the same time, highly individualistic way of looking at things, expressed in the special attention to peculiar and irregular rocks, plants, cloud formations, and architectonic details. We also see this individuality given special expression in Escher's concentration on the structure of space. There is a frequently recurring preference for an angle of view by which different, often strongly contrasting, spatial experiences are emphasized simultaneously.

Again and again we look into a landscape upward and downward as well as into the distance. Examples of this are found in the prints *Bonifacio, Corsica* (no. 31), *Coast of Amalfi* (no. 45), and especially *Castrovalva* (no. 39). In the last of these, we look upward into a formation of clouds, downward into a town in the valley, and into the distance of the mountains stretching before us. Escher preferred the landscape of southern Italy because it so often offered him this range of spatial structures.

In his architectural subjects, too, we repeatedly encounter combinations of different spatial experiences. A typical example is the print *Vaulted Staircase* (no. 46), in which a blend of height and depth coincides with a view to the left and a view to the right. The same combination occurs even more strongly in the print *St. Peter's, Rome* (no. 64).

Although he took the Italian landscape and the architecture of the Italian cities as his main subjects, in these years Escher also worked from time to time on the portrayal of other observations. It is typical of Escher that these prints, too, reveal the attraction of singular or bizarre elements as well as a marked interest in the conjunction of disparate spatial perceptions. His interest in the unusual is exemplified by a remarkable rendering of the phosphorescent wake of dolphins swimming ahead of the bow of a ship at night (no. 17), by a print of fireworks (no. 54), by another of mummified bodies in a church in southern Italy (no. 47), and also by a copy of a bizarre detail from Hieronymus Bosch's painting *The Garden of Delights* (no. 72). The conjunction of different spatial experiences is seen, for instance, in several prints showing mirror effects, the most striking of which are the *Still Life with Mirror* (no. 56) and *Hand with Reflecting Sphere* (no. 63). A mirror effect is preeminently a phenomenon in which widely different spatial circumstances can occur together at a single place. In *Still Life with Mirror,* the space of the street is combined via the mirror with the space of the room, and in *Hand with Reflecting Sphere* the spatial effect of the surface of the sphere coincides with the space around the maker of the print, who sees himself reflected in that surface. During the years before 1937, Escher was not solely concerned with the representation of the observed world but also gave shape in a number of prints to inventions of his own imagination. Typical examples are *Castle in the Air* (no. 26), *Tower of Babel* (no. 27), and *Dream* (no. 70). In the first two we see again a combination of height, distance, and depth. In spatial structure, *Castle in the Air*

bears a relationship to *Castrovalva* (no. 39); *Tower of Babel* to *St. Peter's, Rome* (no. 64). *Dream* is an example of another way of linking different facets of reality, one which Escher used several times during this period. Although the subject as a whole is entirely imaginary, this print is built up of elements that each derive from real observations. Separate observations are combined into a whole (nos. 67-69). For Escher two different forms of reality also coincide in the interpretation of this print. Its meaning is ambiguous: is the bishop dreaming of a praying mantis or is the entire picture the dream of its creator? *Castle in the Air, Tower of Babel,* and *Dream* all show an extravagant world. Their bizarre content has, in addition, a distinctly humorous cast. Humor is expressed in the castle's literal suspension in the air and in the somewhat derisive combination of the two widely divergent forms of prayer in *Dream*—the prayer of the statue of the dead bishop and the prayerful attitude of the mantis.

A strange and highly individual fantasy is shown in the print *Eight Heads* (no. 11) and the closely related pair of drawings with repetitions of an animal motif (nos. 23, 24). These are examples of a way of working that up to 1937 took only a subordinate and isolated place in Escher's work. The remarkable thing, however, is that in these works, too, a combination of different elements of reality is brought about, this time by means of an unusual double use of the contours. In both the print and the drawings, the contours do not serve, as they normally would, to outline a figure against its surroundings but instead delineate figures in two directions, both to the right and to the left. Various figures share the same contours; by these contours they are related to each other, and they are so constructed that they can be repeated, in this linkage, to infinity.

A reference to the possibility of continuation into infinity, as occurs here so distinctly, is, in fact, also present in many of Escher's representations of landscapes and architecture in which different spatial experiences coincide. In these prints, when our gaze is thrust into different directions and far into space, often the suggestion is also created that what we see represented is only one facet of a much greater space comprising different angles of view and continuing into infinity. Besides a preoccupation with reality and his own fantasies, Escher's work from before 1937 shows a passionate concern with the graphic métier as such. In this work he can be seen experimenting repeatedly with the expressive possibilities of graphic techniques—with shading, sharp contrasts between black and white as well as subtle tonal nuances, the use of more than one block for a single print, and the addition of many other technical elements. His choice of sketches for development into prints was determined primarily by their relevance for the technical problem on which he was working at the time. One of the important aspects of the print *Dream* (no. 70) is Escher's experimentation with the technical problem of achieving a gradual transition from light to dark in a woodcut or wood engraving. Here, gray is not an unstructured mixture of black and white but a series of black and white lines. A light area consists of thin black lines alternating with wider white ones. By a gradual widening of the black lines and narrowing of the white ones, the area becomes darker. In *Dream* the rendition of the vaulting offered an especially good opportunity to experiment with this transition from light to dark. The sequence of black and white lines can sometimes be handled in such a way that they contribute toward the effect of perspective; Escher's experiments with this problem are particularly evident in *Tower of Babel* (no. 27). In 1934 he made a series of prints

depicting nocturnal Rome, using a different woodcut technique in each one to create effects of light and dark. In the print *Colonnade of St. Peter s in Rome* (no. 57), for instance, he used only diagonal lines; in *Nocturnal Rome: The Capitoline Hill, Square of "Dioscuro Pollux"* (no. 58), only horizontals; and in *Basilica di Massenzio* (no. 59), he experimented with a particular shading technique.

Up to 1929 Escher worked almost exclusively with woodcut technique. After that period he devoted considerable time to lithography, and after 1931 the refined form of the woodcut—the wood engraving—also took an important place in his work. Except for incidental experiments, he never used the etching technique, which he disliked because the effects are obtained by dark lines placed against a white background. He always preferred to work in and with the surface, which is possible in the woodcut, wood engraving, and lithograph. For Escher, drawing was mainly an approach to his prints. He usually drew to record interesting motifs when he came across them. However, he experimented with this technique, too. The most important of these experiments are the so-called scratch drawings, made by coating parchment evenly with printer's ink and then drawing on this surface by scoring it with a pointed tool. He began to use this technique in 1929 (no. 33); the results were important not only as independent experiments but also because they led him directly to lithography. He found that he could work in the same way on a lithographic stone covered with ink, and his first lithograph, *Goriano Sicoli, Abruzzi* (no. 35), originated as an attempt to apply the scratch technique graphically.

In looking back on his work before 1937, Escher himself was inclined to emphasize experimentation with graphic mediums and to consider most of the works of this period no more than exercises; but we also can recognize in this work a keen observation of the world around him as well as the expression of his own fantasies. In addition, there exists in all this early work a preference for the simultaneous perception and combination of several, often contrasting, facets of reality, which is manifested most often in the spatial structures and occasionally in the contours. We have seen that the linkage of different aspects of reality is usually taken from observations of the visible world but is also sometimes constructed from imagination. We see it here in combinations of angles of view, there in a coinciding of spatial perspective achieved by mirror effects, and again in the combination of separate observations and the double use of the contours. The linkage is present most distinctly in the mirror effects and the double use of contours. However, both these forms occur the least frequently in the work dating from before 1937. This makes it even more remarkable that in Escher's earliest work, done in the period when he was still attending the School for Architectural and Decorative Arts, we encounter examples of both a mirror effect and the double use of contours: the drawing *St. Bavo's, Haarlem* (no. 9) and the print *Eight Heads* (no. 11). In the drawing we look obliquely into the church of St. Bavo. We see part of the ceiling and a hanging candelabrum. In the mirror image on the shiny ball at the base of the candelabrum, we can see part of the rest of the church and, much smaller, the draftsman himself with his easel. The space in which the draftsman is standing and the space at which he is looking are linked by this mirror effect. In *Eight Heads*, as we have already seen, various heads (four male and four female) are linked because their outlines coincide. *St. Bavo's, Haarlem* gives a representation of an observed reality; *Eight Heads* gives a personal construction. Both belong

to Escher's first works but already contain not only the nucleus of his own image-structure but also the principal ways in which it can be expressed. However, such a distinct manifestation of Escher's image-structure as is seen in these two initial works is exceptional for the work done before 1937. It usually emerges in a less obvious way, in combinations of angles of view or in the suggestion of a unity which is actually his own construction based on several individual observations. In 1935 Escher left Italy and, after short stays in Switzerland and Belgium, settled in the Netherlands in 1941. In Switzerland, and to an even greater extent in Belgium and the Netherlands, nature and architecture began to lose the attraction they had had for him in Italy, and he became increasingly absorbed in his own inventions and less and less interested in the portrayal of the visible world. Generally speaking, what had once been only latent and concealed in the early constructions now became openly manifest. The fundamental possibilities stated as early as the *St. Bavo's, Haarlem* and *Eight Heads* were consciously incorporated and developed in this period. This can be seen at a glance in the two prints marking Escher's new phase in 1937: *Still Life and Street* (no. 83) shows a linking of different aspects of space; and *Metamorphosis I* (no. 85), a linking of different figures by the double use of their contours. *Still Life and Street* is closely related to Escher's earlier applications of the mirror effect, particularly the *Still Life with Mirror* (no. 56) of 1934. In both these prints, the space belonging to a room and the space belonging to a street are drawn together.

Despite this structural relationship, however, there is a fundamental difference. In the 1934 print, this linkage is expressed as it would be observed in the real world, whereas in the 1937 print, it has been constructed during the making of the print. Two different observations are combined, one a street recorded in a sketch and the other a view of a worktable with books. We have already seen that a combination of observations made separately at different times and places also occurs in prints such as *Dream* (no. 70); even though the combination is not immediately apparent, we know that it is there. In *Still Life and Street*, however, the independent views are directly evident. Although unity is suggested in this print, too, it is done in such a way that we remain conscious of its literal impossibility, conscious that the suggested unity is due solely to the artist's ingenuity. The observation of the street and the observation of the worktable are cleverly combined in a single perspective, but they remain two separate observations because each is represented on a different scale. There is a unity of space but a difference in scale. This difference in scale is ambiguous: is the worktable with its books abnormally large or is the street absurdly small? The relativity of the concept of scale could hardly be stated with a lighter touch.

The parallel cases formed in Escher's earliest work by the St. Bavo drawing and *Eight Heads* are repeated in 1937, in the two prints *Still Life and Street* and *Metamorphosis I*. The latter shows once again how a contour can not only set off a figure from its surroundings but also have a similar indicative effect in two directions. This print also shows—and this element is not found in *Eight Heads*—how gradual changes in contours can serve to bring about a transformation or metamorphosis. A figure can be modified or can become an entirely different figure.

Escher's copies of the Moorish mosaics in the Alhambra and in La Mezquita (nos. 1 and 75-77), made in the summer of 1936, contributed to his renewed interest in the possibility of a double use of contours. These mosaics are composed of regular repetitions of basic geometric figures that could in principle continue to infinity. They fascinated Escher because he recognized in them problems with which he had been preoccupied several times in 1922 and 1926 but for which no application had occurred to him at that time. The mosaics led him to take up the problem again and to carry it further. His half-brother, B. G. Escher, who held a professorship in geology at the University of Leiden, pointed out to him that crystallography involved the same problem. Using his copies of the Moorish mosaics and the results of some reading in the literature on crystallography, Escher began to construct contiguous, repeated forms of his own. The pure geometry derived from his two sources was not sufficient; he was attempting to reach an essentially different result, for ultimately he was interested not in an interlocking series of abstract patterns but in the linkage of recognizable figures. He tried to bring abstract patterns to life by substituting them with animals, plants, or people. He had an inherent need to give these abstract patterns form by means of clearly recognizable signs or symbols of the living or inanimate objects surrounding us. Working from the abstract geometric figures taken from the Moorish mosaics and crystal formations, Escher developed innumerable realistic figures that, when linked in contiguous symmetrical series, could be repeated to infinity. Step by step, he filled his notebooks with these motifs until he had an inexhaustible supply of source material for his prints.

In the prints in which Escher used these motifs, the process leading to the animation of abstract structures is carried still further. The bringing to life of an abstract structure of contiguous repetitions produces individualization of this structure, which, carried to its logical conclusion, means that it will ultimately become finite. The motifs constituting the regular division of the surface, which in themselves could be continued to infinity, were now individualized to such a degree that their structure acquired a beginning and an end. What we see in these prints is no longer a fragment but a whole, a completed picture.

Metamorphosis I (nos. 84, 85) is an excellent example of this development from motif to complete entity. The point of departure for this print was a motif consisting of contiguous repetitions of a small Chinese man. The drawing shows clearly that the underlying structure of this motif is formed of a regular division of the surface into equilateral triangles. Like these triangles, the little men in the drawing are only fragments of a structure that could continue to infinity; but in the print this structure is used to create a picture containing its own resolution. Toward the right, the little man becomes increasingly detailed, until he finally releases himself from the series; as an independent individual, he takes a position against a background. In the middle of the print, he transforms himself into connecting hexagons, which, in their turn, undergo a gradual transformation into the houses of the Italian town occupying the left side of the print.

The possibilities inherent in this animation or individualization of basic motifs were worked out in innumerable prints, each time in a different way. One of the striking things about these prints is how frequently the genesis of the individualized figures is accomplished not only by a gradual differentiation of a given geometric structure but also by the use of a vague gray tone that makes a gradual transition into a sharp black-and-white contrast. For Escher, this vague gray is another basic element that can be brought to life. We see this clearly in the print called *Development I* (no. 86), dated 1937. A complex structural variant of *Development I* is offered

by *Verbum* (no. 99), done in 1942. Unlike *Development I*, *Verbum* does not represent the process of individualization from the margins toward the center but the reverse, from the center outward. In this print, we see an indefinite central gray area differentiate itself into a motif of contiguous black and white triangles, which in turn gradually change into birds, fish, and reptiles, symbolizing air, water, and earth. Each of these animal species manifests itself in both black and white versions, thereby indicating day and night. These contrasting figures originate not only from the same gray tone and the same abstract motif but also from each other. In a clockwise direction, the birds change into fish; the fish, into reptiles; and the reptiles, back into birds. At the outer margins, where the animals are individualized, this movement simultaneously becomes a complex exchange of foreground and background. The white day behind the black birds gives rise to white birds, while the black birds become the black night behind the white birds. The white birds merge with the white day behind the black fish, which, in their turn, derive from the black night, and so on.

The movement by which the birds, fish, and reptiles are transformed into each other in *Verbum* forms a closed cycle, a feature recurring in many of Escher's prints. The closed cycle fascinates him because with it something of infinity can be captured within the finite. We see closed cycles in such prints as *Reptiles* (no. 102), *Magic Mirror* (no. 108), *Swans* (no. 151), and *Cycle* (no. 90). An especially good example is *Day and Night* (no. 88), in which an interlocking series of diamond-shaped figures gradually becomes a contiguous series of black and white birds. These birds are each other's mirror images, and they fly in opposite directions. As they approach the sides of the print, they release themselves from their neighbors; the white birds gradually become the diurnal landscape behind the black birds, and the black birds, the nocturnal landscape behind the white birds. It seems now as though an individualization has been completed on both sides; but then we see that the diurnal and nocturnal landscapes, too, form each other's mirror image. Furthermore, the landscapes are composed of fields, and, in the lower central portion of the print, the fields take on the shape of a contiguous series of diamonds. These diamonds connect the diurnal and nocturnal landscapes, but at the same time they are the figures from which the birds developed, and so they generate two closed cycles, a left and a right, which mesh like two cogwheels. It is typical that here, too, the animation of an abstract motif is accompanied by a differentiation of gray into sharp contrasts of black and white.

An individual combination of finite and infinite is illustrated by the prints *Circle Limit I* (no. 163), *Circle Limit III* (no. 7), and *Circle Limit IV* (no. 171). A motif to regularly fill the surface is used radially in these prints, with the concentric rings of the motif becoming smaller and smaller in an exactly executed process of reduction. Although this reduction can in principle continue to infinity, it is at the same time limited by the circle to which it gives rise. Escher first attempted to suggest the infinitely small by progressively reducing the motif by half toward the center, as in *Smaller and Smaller I* (no. 6). But this print left Escher unsatisfied, because the result was an artificial limitation at the outer margins and therefore only a fragment, rather than a self-enclosing composition. In this respect the reverse approach used in the *Circle Limit* prints—the reduction toward the margins—is much more successful; a suggestion of the infinitely small is visible in a composition forming a self-contained whole (see also page 16).

Escher also combined finite and infinite in a more complicated version of *Metamorphosis I*. Done in 1939, this new version, *Metamorphosis II* (no. 95), was more than four times longer and much more complex; in it, he converted the individualized and completed process of the 1937 *Metamorphosis I* (no. 85) into a suggestion of a closed cycle. In place of the man and the town at the two extremes, Escher now made the beginning and the end of the print coincide. If the ends of the print were joined to form a cylinder, the patterns at the beginning and the end would merge.

In its continuous motion, this print also demonstrates many of the possibilities of linkage and permutation. We see not only transformations dependent on form but also transformations determined by the content of the subject. When hexagons change into honeycombs, this is the result of an association of the form; but when Escher makes bees fly out of the honeycomb, this is a logical possibility suggested by the content. Another shift determined by such an association is the transformation of the tower into a rook in the chess game. Escher had always taken immense pleasure in playing with associations. As a child he set himself riddles such as: how can a logical connection be drawn between the letter *l* and my dog's tail? One answer would be, for instance: by starting with the *l* of *lucht* (air) and then going via bird—nest—branch—garden—dog to tail. Many of his prints, exemplified by *Metamorphosis II*, constitute a visual demonstration of this kind of game. We have seen that *St. Bavo's, Haarlem* was done in the same period as *Eight Heads* and that in 1937 Escher produced not only *Metamorphosis I* but also *Still Life and Street*. A parallel interest in surface-filling motifs and spatial structures can also be seen in the drawings Escher made in 1936 at La Mezquita in Córdoba, where he not only copied the regular repetitions of the mosaics (no. 77) but was also fascinated by the perspective effects created by the long rows of columns. In the drawing *La Mezquita, Córdoba* (no. 75), we see the coinciding of a distant view to the left and a distant view to the right. This drawing corresponds to a series of prints reflecting related observations, such as *Vaulted Staircase* (no. 46) and *St. Peter's, Rome* (no. 64). Because the drawing remains in every way a realistic representation of the observable world, it does not anticipate the coming work as clearly as the copies of the mosaics, but it is not surprising that it originated in parallel with these copies.

Although in 1937 Escher produced both an original construction based on surface-filling motifs (*Metamorphosis I*) and an original compositional construction with spaces (*Still Life and Street*), his work during the next few years shows a distinct preference for the former direction. In a certain sense, this is logical. Original pictorial constructions were directly present in Escher's work before 1937, especially in the occasional drawings and prints with contiguous series, so it is understandable that these early works took on a special importance when he began to concentrate on pictorial constructions after 1937. This trend was further solidified by his contact with the Moorish mosaics and crystallography, which suddenly made him conscious of the many unsuspected possibilities in this area. During the first few years after 1937, the use of repetitive motifs, rather than spatial structures, offered Escher greater opportunity to create an individual pictorial construction and thus to express himself in a highly individual way. When Escher spoke of his own work, he named this field of surface-filling constructions as his richest source of inspiration. However, by this analysis, Escher gave a very one-sided vision of his work. This statement applies only

to the years shortly after 1937; after that period, and particularly after 1944, he began to concentrate once again on his own spatial compositions.

The experimentation with spatial constructions after 1944 led Escher to more and more surprising results; good examples are given by *Other World* (no. 116), *Relativity* (no. 142), and *Belvedere* (no. 160). In these prints we see recognizable figures and spaces in impossible situations, where they possess an absurd strangeness. *Other World* shows within a single space the same bird figure and architecture seen from above, below, and the side. *Relativity* contains many remarkable elements, such as the two figures in the upper part of the print who are walking on the same stairs in the same direction but one ascending and the other descending. Startling phenomena are also found in *Belvedere*—a ladder begins inside and ends outside the building but can still be climbed normally, and a man and a woman look out through two openings in the same wall, one directly above the other, although the man is looking obliquely away from us into the distance and the woman obliquely toward us. The singularities in these prints are the result of an ingenious linkage of different spatial realities. These connections are not established arbitrarily; in each case there is a particular underlying principle, worked out logically to the last detail. Consequently, what seems absurd in relation to our normal experience is presented in these prints as a logical possibility of a deliberate visual system. The singularities in *Other World* and *Relativity* result from the fact that in these prints each plane has been given not the usual single function but three: each flat surface is at the same time wall, floor, and ceiling. The absurd building in *Belvedere* is constructed according to the principle—possible only on paper—of a cube whose edges have been exchanged. The figure on the bench has such a cube in his hands, thus illustrating the structure of the print. The transposition of the edges is expressed in the building by the columns of the second story. Because here our attention is purposely distracted in a very subtle way to the mountainous landscape in the background, we must make a deliberate effort to observe this exchange.

As in the prints based on surface-filling motifs, in the spatial constructions an abstract principle is always brought to life by means of recognizable motifs. This animation or "narrativization" was achieved step by step in numerous studies. Good examples of this process are provided by the studies for the *House of Stairs* (nos. 131-134). We can follow the introduction of the narrative element into an abstract structure especially clearly in the studies leading up to the *Waterfall* print (nos. 173-180). The point of departure in this case was a perspective drawing of a triangle published by L. S. and R. Penrose ("Impossible Objects, A Special Type of Visual Illusion," *The British Journal of Psychology*, February, 1958). No error can be discovered in any of the subsidiary elements of this triangle (no. 173), but the whole is impossible because the manner in which these parts have been related to each other admits modifications. In Escher's drawings we can see how he gradually transformed this figure into an extraordinary building with an impossible waterfall that feeds itself and can only cease to exist if the water is lost by evaporation. Typically, the surroundings of this waterfall are composed of reminiscences of Italian landscapes, and even the wondrous fantasy of a garden is based on a drawing Escher made many years earlier.

The grafting of a narrative onto an abstract structure is itself never visible in the completed prints of spatial constructions. The generative processes, such as we have seen in *Verbum* or *Day and Night*, do not occur in the final prints. When in rare cases the underlying framework of the print is recognizably conveyed in the completed picture, it is always done in a static manner. In *Belvedere* the figure on the bench reveals the structure of the print by the cube in his hand, but we do not actually see the picture evolve from this structure. In the same static manner, the structure of *Convex and Concave* (no. 147) is indicated on the flag at the upper right. On this flag we see a group of three cubes, which we can read in two ways. At one moment we see three standing cubes, at another moment three cubes lying on their sides; the two gray planes in the middle of the group can form either the upper surface of two of the standing cubes or the lower surface of two of the cubes on their sides. The rest of the print consists of a narrative manipulation of this structure; for example, the surface on which a man sits at the lower left is the same surface from which an oil lamp is suspended at the lower right. We have already mentioned that in the representation of spaces before 1937, there is a suggestion that what we see is only a fragment of a much greater space extending to infinity. Various prints showing spatial constructions from the period after 1937 also contain a very explicit suggestion of endlessness, for example, *Cubic Space Division* (no. 140) and *Depth* (no. 5). Structurally, these prints are directly related to drawings like *La Mezquita*, while at the same time showing a shift from observation of reality to invented construction.

A print such as *House of Stairs I* (no. 135) contains a suggestion of infinity in that the subject can be repeated endlessly in both downward and upward directions. Because the upper and lower margins fit together perfectly, this repetition can even be accomplished literally by repeated printings of the lithographic stone (no. 136).

The pictorial constructions with spaces contain not only suggestions of the infinite but also repeated changes from one reality to the other, with the structure of a closed cycle. In *Waterfall* (no. 180), for instance, the water flows endlessly in its circular course. In *Ascending and Descending* (no. 167), one group of monks climbs eternally and the other descends endlessly. In an unusually complicated construction, *Print Gallery* (no. 153) shows a boy watching himself viewing a print, with the boy who is looking and the boy who is being looked at coinciding.

Invented compositions dominated Escher's work after 1937, and recorded observations of the real world became much less important. The few occasions on which Escher returned to the realm of observation mainly concerned mirror effects; the best examples are *Three Worlds* (no. 149) and *Three Spheres II* (no. 109). In *Three Worlds* the water of the pond functions as a surface, as depth, and as reflector of the world above it. *Three Spheres II* is an elaboration of *Hand with Reflecting Sphere* (no. 63) of 1935; in a still clearer way, Escher showed once again how various spaces coincide in this mirror effect and how, in the process of representing this coincidence, the maker is inevitably present at the center. Escher's prints are always concerned with a search for a logical connection between the many forms in which reality is manifested. This connection can be observed or constructed. In *Three Spheres II*, he shows how even when it is observed, the connection is, in the final analysis, his own construction. Observer and creator are not separate but indivisibly connected.

After 1937, experimentation with graphic techniques also became much less important for Escher and recurred with true passion only between 1946 and 1951, when he

Fig. 1. Samuel Jessurun de Mesquita. *Self-Portrait*. 1917. Woodcut

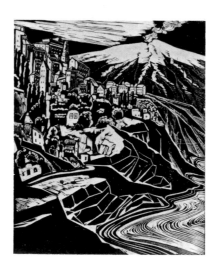

Fig. 2. J. G. Veldheer. *Mt. Etna*. c. 1930. Woodcut

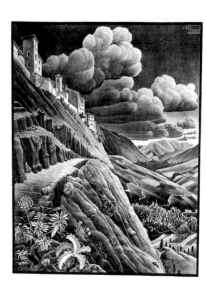

Fig. 3. M. C. Escher. *Castrovalva*. 1930. Lithograph (no. 39)

attempted to master the technique of the mezzotint. But this experiment was limited (see nos. 110, 113-115, 119, 121, 129)—enough, it may be said in passing, to show that he had acquired complete mastery of this difficult technique. But he felt that these experiments cost him more time than he wanted to spare, time he needed for working out the unending succession of pictorial constructions that welled up in his mind. Generally speaking, after 1937 technique became no more than a means for giving form to his conceptions; from that date on he employed the technique most suitable for presenting the idea with which he was occupied and not the other way around, as had often been the case. But his affection for manual skill never entirely disappeared; though it became subordinate to the content, the actual making of a print continued to give him great pleasure, and he tried to do as much of his own printing as possible. Especially in the last few years, when he rarely created new work, he spent most of his working day printing. He complained about the number of orders to be filled, but at the same time he enjoyed the wide distribution of his work. After all, he became a graphic artist because he wished to be able to offer multiple examples of each idea. He made very large editions of his prints, usually more than a hundred and occasionally more than a thousand. He exploited to the utmost the possibilities for multiplication offered by graphic techniques. The unique held little interest for Escher; repetition fascinated him.

If we consider Escher's work as a whole, we can distinguish both before and after 1937 a preference for combinations of various facets of reality. In the work done before 1937, we find a distinct accent on spatial structures; only in occasional instances does Escher play with surface-filling motifs, giving the contours a linking function. After 1937 the accent shifts first to the surface-filling motifs, but particularly after 1944 he also experiments intensively with spatial relationships. Before 1937 we see a secondary emphasis on recording reality, but after that date invented constructions become most important. We could say that what was only latent in the first phase became completely manifest in the second phase; this progression occurring rather rapidly and radically. Besides this change and a growing technical control, Escher's work has actually undergone no important development. He consistently creates ingenious variations on the original thematic material

which remains the nucleus of his entire oeuvre.

In many respects Escher's work is extremely compact, and his prints repeatedly refer to each other. We can divide them into various groups, but each time we begin to do so it becomes apparent that other combinations are equally possible, that innumerable other relationships are also present. For instance, *Magic Mirror* (no. 108), *Horseman* (no. 112), and *Swans* (no. 151), which are all composed of surface-filling motifs, show a spiral closed cycle that we also find in spatial constructions such as *Print Gallery* (no. 153), *Spirals* (no. 143), *Moebius Strip I* (no. 172), *Knots* (no. 182). There is an unmistakable relationship between *Convex and Concave* (no. 147), a play on space, and *Day and Night* (no. 88), a composition of repeated motifs. Both prints have a stable subject laterally but in the middle show a perpetual conflict between the different ways in which the pictorial elements can be read. In *Day and Night* this conflict is between foreground and background; in *Convex and Concave*, as the title itself indicates, between these two opposites. Close analysis also shows a distinct agreement between *Three Worlds* (no. 149) and *Other World* (no. 116), two prints which at first sight seem to have little to do with each other. In both, three spaces are linked because a single plane has not one but three spatial functions. In *Other World* wall, floor, and ceiling coincide; in *Three Worlds*, depth, height, and surface. There is also a similarity between *Order and Chaos* (no. 125) and *Circle Limit I* (no. 163). Both show a fascination with and appreciation of a mathematical figure. *Order and Chaos* employs an existing mathematical figure, a dodecahedron, in the form of a star; *Circle Limit I* contains Escher's own construction of a mathematical figure—a radially diminishing motif of contiguous fish based on an accurately executed division of the dimensions by two.

An interest in mathematical and especially geometric basic figures is one of the constants in Escher's work; this element, too, was latent before 1937 and only emerged fully after 1937. The prism-like basic forms which are latent in *Goriano Sicoli, Abruzzi* (no. 35), done in 1929, and *Morano, Calabria* (no. 43), of 1930, but which are nevertheless indicated by the way in which the small cities are placed in the landscape, have become manifest in such later prints as *Stars* (no. 123), *Order and Chaos* (no. 125), and *Tetrahedral Planetoid* (no. 144). The same progression from implied to explicit is seen in the

Fig. 4. Chris Lebeau. Poster (detail). c. 1910. Woodcut

Fig. 5. Diagrams for unending ornamental motifs, from N. J. van de Vecht, *De grondslag voor het ontwerpen van vlakke versiering,* Rotterdam, 1930

early print *San Gimignano* (no. 14) and the drawing *Palm Tree* (no. 18) on the one hand, and a later print like *Spirals* (no. 143) on the other.

Still another lasting characteristic of Escher's work is a bizarre sense of fantasy combined with a highly individual sense of humor, as can be seen from almost any of the prints. Here there is no development from latent to manifest—this element is just as distinct in *St. Francis* (no. 13), done in 1922, in which not only the saint but also some of the animals have been given a halo, as it is in *Curl-up* of 1951 (no. 130), in which this little animal with its rolling locomotion is presented as a scientific discovery. Escher's humor is often characterized by a sarcastic reference to comparative values. The haloes around the animals are a comment on the halo around St. Francis. Escher considered it a joke that a biblical interpretation is usually given to the little book of "Job" in *Reptiles* (no. 102) when actually it is only a packet of a Belgian brand of cigarette papers. Even a fascinating construction like *Ascending and Descending* (no. 167) is not without its touch of sarcasm, although to appreciate why it is monks who ascend and descend into infinity one must know that the Dutch term for useless labor is "monk's work."

Up to this point, we have examined Escher's work from the inside. But we can also approach it from the outside and relate it to other developments in the field of art. Escher's work is to a high degree unique; nevertheless, it cannot be completely isolated from other artistic developments. Escher's first prints are related to the work of his teacher, Jessurun de Mesquita. We repeatedly see in them a stolid and angular style resembling Mesquita's (Fig. 1). Escher's preference for the woodcut technique and his passion for technical experimentation are also directly related to what he learned from his mentor, who was known for his endless experiments, especially with woodcuts. This early output not only bears a relation to Mesquita's work but actually forms part of what was at that time a vital Dutch graphic tradition, characterized by a combination of late Art Nouveau, a mild Expressionism, and Realism, with an emphasis on craft and technique. Other artists who worked in this tradition were Jan Mankes, Chris Lebeau, Jan Wittenberg, and J. G. Veldheer, to name only a few. Since Veldheer, like Escher, often worked in Italy during the twenties and thirties, it is interesting to compare his

Italian landscapes, for instance his *Mt. Etna* woodcut (Fig. 2), with Escher's Italian landscapes, such as the *Sicily* (no. 51), *Morano, Calabria* (no. 43), and *Castrovalva* (Fig. 3; no. 39) prints. There is certainly an agreement in style and atmosphere. But we see how much tighter and more systematic Escher's prints are and, in particular, how much more clearly accentuated the perspectives and spatial planes. This difference in the treatment of space is clearly illustrated by *Castrovalva,* which concerns roughly the same kind of situation as Veldheer's landscape in *Mt. Etna.* A comparison of the two makes us conscious of the fact that emphasizing different spatial aspects such as height, depth, and distance is characteristic of Escher's work.

Strictly individual, too, is Escher's interest in reflections, which is not present in the work of such artists as Mankes, Veldheer, and others. It is remarkable, however, that in the tradition in which Escher began, we do here and there encounter surface-filling motifs. A poster designed by Chris Lebeau around 1910 carries a border motif of linked fish (Fig. 4), and in a book on ornamentation frequently used in this tradition, *De grondslag voor het ontwerpen van vlakke versiering* (Fundamentals for the Design of Surface Ornamentation) by N. J. van de Vecht (Rotterdam, 1930), we even find diagrams for unending ornamental motifs (Fig. 5). Thus, the area-covering designs that came to play such a large part in Escher's work were related not only to the Moorish mosaics but also to elements in his own national tradition. But, as we have seen, he began to use these motifs in a way that was entirely his own—not subordinately, solely as ornaments, but as his main subjects or as basic vehicles for expressing special ideas. Although in many of its aspects Escher's first work fits into an existing tradition, it also had from the very beginning individual basic themes which bore little relation to this tradition. As we have seen, these themes, expressed as the linking and combining of different, often opposing, aspects of reality, were Escher's own creations. When they became fully manifest after 1937, his work became almost entirely independent of the tradition from which it had sprung. Although the work after 1937 often appears so unique that there seems to be nothing with which it can be compared, this is only partially true. In the art of different places and times we repeatedly encounter works that show in a certain sense parallel thematic material. For instance, there is a related

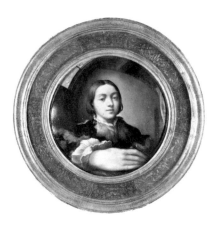

Fig. 6. Parmigianino. *Self-Portrait*. 1524. Oil on panel. Kunsthistorisches Museum, Vienna

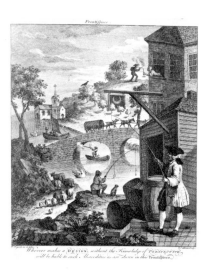

Fig. 7. William Hogarth. Frontispiece to *Dr. Brook Taylor's Method of Perspective*. 1754. Engraving. British Museum, London

interest in reflections in a Mannerist portrait by Parmigianino (Fig. 6) and a related impossible spatial construction in a print by Hogarth (Fig. 7). We have already pointed out how Escher himself encountered a preoccupation with surface-filling motifs in the Moorish mosaics, and we know that he greatly admired some of Piranesi's prints because their tangle of dizzy spaces accorded with his own feeling for space.

Up to the twentieth century, however, those works of European art which bear any relation to Escher really occur only in peripheral areas and do not belong to the main movements of their times. What is remarkable, however, is that in the twentieth century we see works belonging to a few of the main currents of European art that have developed independently but have a distinct structural relationship to the basic thematic material of Escher's prints. They show that Escher's work, although apparently isolated, is nevertheless in certain aspects closely related to the major developments of art in the twentieth century.

The series of trees done by Piet Mondrian in 1912 (Fig. 8) are often cited as a clarifying example of the radical change that took place in art at the beginning of the present century. In this series we see how a recognizable tree can gradually change into an abstract structure, how the large shape of the tree is converted into a series of small shapes, and how the contrast between foreground and background is simultaneously abolished. For Mondrian, at some time around 1912, the unquestioned unity of the visual world, as present in a traditional perspectivistic construction, was suddenly no longer self-evident. In the customary representation using perspective, there is always a clear distinction between foreground and background, between what is of principal importance and what is incidental. For Mondrian, this distinction between elements of unequal importance became unbearable, for in his opinion visible reality was composed of essentially equivalent elements. To abolish the inequalities inherent in a perspective representation, he changed the tree, ground, and air into small, equally important components which, without a contrast between foreground and background, are directly linked with each other.

Another modification of traditional perspective is found in Paul Citroen's photo-collage *Metropolis* of 1923 (Fig. 10), one of the best known early examples of this technique which was to play such an important part in

modern art. In this photo-collage a city is represented from many viewpoints simultaneously. Different photographs of the same city are combined. The space belonging to each one has a traditional perspective; but the juxtaposition of the separate photographs illustrates the limitations of that perspective. In this photo-collage, too, there is no unalterable unity with a sharp distinction of foreground and background but rather an accumulation of equally important elements.

Although Escher's prints may seem at first to bear little relation to these works by Mondrian and Citroen, a closer analysis shows that all three approaches have a similar structure. In Escher's prints, too, visible reality has lost its intrinsic unity. *Day and Night* (Fig. 9; no. 88) contains a process that is related to the process in Mondrian's trees. In the lateral parts of the print, there is an apparently normal relationship between foreground and background and thus between main and subsidiary elements, but the middle part of the print shows that these concepts are to a high degree relative and that the elements involved in them can even exchange roles. As in Mondrian's process of abstraction of a tree, here the contrasting dominant and subordinate components are converted into equally important small elements that are directly related. A print like *Other World* (Fig. 11; no. 116) is related to Citroen's collage because it contains not a single viewpoint but rather a combination of different angles of view on the same situation. In Escher's print, as in Citroen's collage, each individual viewpoint is shown in a traditional, perspectivistic manner, but the intrinsic unity of the representation is shaken because the different views are directly connected.

In the art of the twentieth century, visible reality has lost its apparent unity and has become a multiplicity of visual phenomena, which are all equally unique. The central problem of modern art is how to organize coherently the many different visual elements without reducing the uniqueness of each. Escher's basic thematic material is essentially connected with this problem. For him, too, visual reality is not singular but plural. We have seen in his prints a repeated search for new relationships between the many and often contrasting forms in which the observed world is manifested. As a result he alternately concentrates on the limits, the outlines—which leads to the filling of surfaces—and on the spatial structure and relationship of things. The simultaneous occurrence of these two lines of

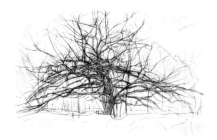 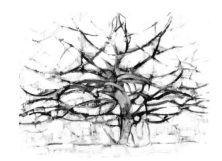

Fig. 8. Piet Mondrian
Tree II. 1912. Black chalk on paper.
Gemeentemuseum, The Hague *The Gray Tree.* 1912. Oil on canvas *Flowering Apple Tree.* 1912. Oil on canvas

development is also found in the main currents of modern art. We have seen how Mondrian changed the values of the outline of a tree, which led to an abstract sequential covering of area; and how Citroen manipulated many views of a city, which led to a combination of spaces. In Cubism and the *De Stijl* movement, the central concern is a relativization of contours; and in Dadaism and Surrealism, a relativization of space. What was begun by these movements is still a source of experimentation for contemporary artists.

Despite their similarity in certain aspects, there is an important difference between Escher's work and most modern art. They are related in their basic structure, but Escher's use of this structure is unique. The multiplication of visual reality is interpreted in Dadaism and Surrealism as chaotic and absurd, but in Escher it is rational; it contains not chaos but order. In Citroen's photo-collage, a combination of spatial observations is created in an intuitive, chaotic manner, but in Escher's *Other World* various spatial realities are linked in a strictly rational way—the picture forms a logical and self-enclosing whole. It is typical of Escher's work that the shifts in spatial relationships take place within a total composition using traditional perspective. All the separate viewpoints are dependent on the same vanishing point. In Citroen there is only a chaotic linking of separate and conflicting images, and therefore the total is not self-enclosed but open.

This difference can also be seen between Mondrian's trees and Escher's *Day and Night*. Mondrian's abstraction of the outlines of the tree is based on feeling, in contrast to the simplification of the contours of the birds in *Day and Night*, which is again the consequence of a logical principle. The abstraction developed by Mondrian in three successive works is completed by Escher in a single print. And in Escher's work there is not only a progression from a recognizable world to an abstract motif, for instance from polders to diamonds, but in particular the reverse development from an abstract motif to a recognizable world, for instance from diamonds to birds. There is a two-way movement between an abstract principle and a narrative world—all within a self-enclosing representation. Here, too, the composition as a whole is constructed using traditional perspective, and the relativization of this perspective occurs only within it.

As a further development of the work of such artists as Mondrian, recent art is repeatedly concerned with abstract visual constructions which are organized according to a fixed principle and which no longer have any emotional content in their structure. In these works visible reality is seen not as chaos but as order. In this respect they are related to Escher's work. But only very rarely, if at all, does anyone work as logically as does Escher in his prints. Furthermore, this recent art is concerned exclusively with abstract structures as such; for Escher, however, it is of essential importance that an abstract principle be made narrative through recognizable motifs.

In the traditional art world, Escher's work has always been regarded with a certain reserve, and he has never been highly esteemed. Respect has been paid the mastery of graphic techniques and the great originality shown in his prints, but otherwise his work is considered to be too intellectual and to lack a lyrical quality. In certain recent art currents, there is a deliberate effort to be, like Escher, intellectual and not very lyrical, and, as with Escher, the primary concern is the consistent and logical development of a given principle or concept. But in this quarter, too, there is little interest in Escher's work, in this case because of a dislike of his traditional narrative motifs and of his preservation of traditional perspective for space in the composition as a whole. Although these two reasons explain why Escher has never been highly regarded in the art world, they are, however, directly responsible for his fame outside it. In his prints conventional and therefore easily recognizable motifs are used to give form to a modern pluralistic picture of the world. This new concept of reality is not present in traditional representations of landscapes, still lifes, or portraits. And although it occurs in movements such as Cubism, *De Stijl*, Dadaism, Surrealism, and the recent continuations of these currents, their visual language is still readable only for a small number of specialists. In Escher's prints, on the contrary, there is a traditional, realistic visual language that almost anyone can read.

It is typical of this difference in esteem inside and outside the art world that in a recent number of the journal *Delta* (Winter, 1969-70) devoted to art in the Netherlands during the past twenty-five years, not one of Escher's prints is reproduced or discussed, in spite of the fact that it has been in just this period that Escher's work has

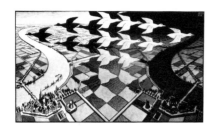

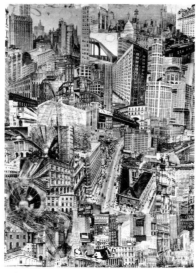

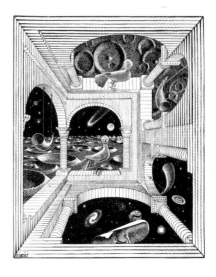

Fig. 9. M. C. Escher. *Day and Night.* 1938. Woodcut (no. 88)

Fig. 10. Paul Citroen. *Metropolis.* 1923. Photo-collage

Fig. 11. M. C. Escher. *Other World.* 1947. Wood engraving (no. 116)

attracted so much attention both in the Netherlands and abroad. His works are now being widely studied and collected and are being used on contemporary posters and records, and especially as illustrations in many popular books and specialized scientific publications. It is striking that although in general there is a distinct cleavage between art and science at the present time, Escher's work has gained international fame among scientists. Articles published in *The Studio, Time,* and *Life* had given him an international name as early as 1951, but it was an exhibition of his work in September, 1954, in the Stedelijk Museum in Amsterdam, organized on the occasion of an international congress of mathematicians, that marked the beginning of this phase of popularity in the scientific community. This exhibition was an enormous success and brought Escher into contact with many scientists and theoreticians. In the years that followed, he was invited to other conventions to lecture on his work. Scientists are fascinated by Escher's work because they recognize in it not only a concept of the world with which they are familiar but also a similar attitude toward that world. For them as for him, the plurality of the world signifies neither absurdity nor chaos but a challenge to look for new logical relationships between phenomena. The strangeness or absurdity that seems at first sight to be present in Escher's prints can, in the final analysis, be solved and explained. This is a main source of fascination in Escher's prints. In them reality is wondrous and at the same time comprehensible.

Abstract

1 In Escher's work there is an interaction between a given structure and a recognizable world. Before 1937 the recognizable world served as the starting point from which a structure was to be reached. But after 1937 the structure became the starting point and was made visible by means of recognizable motifs. In *Castrovalva* (no. 39), for instance, visible reality is seen in a way that gives rise to a structural combination of height, depth, and distance. In *Other World* (no. 116) the principle that a surface can be given three spatial functions is elucidated by means of a recognizable bird in a recognizable architecture.
2 Escher's structuralism is expressed primarily in a linkage of contours and a linkage of spaces. Both concern interrelationships in a pluralistic vision of the world.
3 A pluralistic concept of the world also belongs to the main currents in modern art, but with the following differences. In Escher the plurality of the world does not mean chaos but order, and he is never concerned solely with plural structures as such but rather with an interaction between structures and recognizable motifs.
4 A pluralistic concept of the world, seen as orderly and as a challenge to find new logical relationships between phenomena, combined with inseparability of structure and narration, has led to Escher's solid reputation among scientists as well as a very large public which is generally uninterested in what is considered today to be typically modern art.

Approaches to Infinity

M. C. Escher

Man is incapable of imagining that time could ever stop. For us, even if the earth should cease turning on its axis and revolving around the sun, even if there were no longer days and nights, summers and winters, time would continue to flow on eternally.

It is no easier for us to imagine that somewhere, past the farthest stars in the nocturnal heavens, there is an end to space, a borderline beyond which "nothing" exists. The concept "empty" does have some meaning for us, because we can at least visualize a space that is empty, but "nothing," in the sense of "spaceless," is beyond our capacity to imagine. This is why, since the time when man came to lie, sit, and stand on this earth of ours, to creep and walk on it, to sail, ride, and fly over it (and now fly away from it), we have clung to illusions—to a hereafter, a purgatory, a heaven and a hell, a rebirth or a nirvana, all existing eternally in time and endlessly in space.

Has a composer, an artist for whom time is the basis on which he elaborates, ever felt the wish to approach eternity by means of sounds? I do not know, but if he has, I imagine that he found the means at his disposal inadequate to satisfy that wish. How could a composer succeed in evoking the suggestion of something that does not come to an end? Music is not there before it begins or after it ends. It is present only while our ears receive the sound vibrations of which it consists. A stream of pleasant sounds that continues uninterrupted through an entire day does not produce a suggestion of eternity but rather fatigue and irritation. Not even the most obsessive radio listener would ever receive any notion of eternity by leaving his set on from early morning to late in the night, even if he selected only lofty classical programs.

No, this problem of eternity is even more difficult to solve with dynamics than with statics, where the aim is to penetrate, by means of static, visually observable images on the surface of a simple piece of drawing paper, to the deepest endlessness.

It seems doubtful that there are many contemporary draftsmen, graphic artists, painters, and sculptors in whom such a wish arises. In our time they are driven more by impulses that they cannot and do not wish to define, by an urge which cannot be described intellectually in words but can only be felt unconsciously or subconsciously.

Nevertheless, it can apparently happen that someone, without much exact learning and with little of the information collected by earlier generations in his head, that such an individual, passing his days like other artists in the creation of more or less fantastic pictures, can one day feel ripen in himself a conscious wish to use his imaginary images to approach infinity as purely and as closely as possible.

Deep, deep infinity! Quietness. To dream away from the tensions of daily living; to sail over a calm sea at the prow of a ship, toward a horizon that always recedes; to stare at the passing waves and listen to their monotonous soft murmur; to dream away into unconsciousness...

Anyone who plunges into infinity, in both time and space, further and further without stopping, needs fixed points, mileposts, for otherwise his movement is indistinguishable from standing still. There must be stars past which he shoots, beacons from which he can measure the distance he has traversed.

He must divide his universe into distances of a given length, into compartments recurring in an endless series. Each time he passes a borderline between one compartment and the next, his clock ticks. Anyone who wishes to create a universe on a two-dimensional surface (he deludes himself, because our three-dimensional world does not permit a reality of two nor of our dimensions) notices that time passes while he is working on his creation. But when he has finished and looks at what he has done, he sees something that is static and timeless; in his picture no clock ticks and there is only a flat, unmoving surface.

No one can draw a line that is not a boundary line; every line splits a singularity into a plurality. Every closed contour, no matter what its shape, whether a perfect circle or an irregular random form, evokes in addition the notions of "inside" and "outside" and the suggestion of "near" and "far away," of "object" and "background." The dynamic, regular ticking of the clock each time we pass a boundary line on our journey through space is no longer heard, but we can replace it, in our static medium, by the periodic repetition of similarly shaped figures on our paper surface, closed forms which border on each other, determine each other's shape, and fill the surface in every direction as far as we wish.

What kind of figures? Irregular, shapeless spots incapable of evoking associative ideas in us? Or abstract, geometrical, linear figures, rectangles or hexagons at most suggesting a chess board or honeycomb? No, we are not blind, deaf, and dumb; we consciously regard the forms surrounding us and, in their great variety, speaking to us in a distinct and exciting language. Consequently, the forms with which we compose the divisions of our surface must be recognizable as signs, as distinct symbols of the living or dead matter around us. If we create a universe, let it not be abstract or vague but rather let it concretely represent recognizable things. Let us construct a two-dimensional universe out of an infinitely large number of identical but distinctly recognizable components. It could be a universe of stones, stars, plants, animals, or people.

What has been achieved with the orderly division of the surface in *Study of Regular Division of the Plane with Reptiles* (no. 2)? Not yet true infinity but nevertheless a fragment of it, a piece of the universe of the reptiles. If the surface on which they fit together were infinitely large, an infinitely large number of them could have been represented. But this is not a matter of an intellectual game; we are aware that we live in a material, three-dimensional reality, and we are unable in any way to fabricate a flat surface extending infinitely on all sides. What we *can* do is to bend the piece of paper on which this reptilian world is represented fragmentarily and make a paper cylinder of it so that the animal figures on that cylindrical surface continue without interruption to interlock while the tube revolves around its longitudinal axis. In this way, endlessness is achieved in one direction but not yet in all directions, because we are no more able to make an infinitely long cylinder than an infinitely extending flat surface. *Sphere with Fish* (no. 97) gives a more satisfactory solution: a wooden ball whose surface is completely filled by twelve congruent fish figures. If one turns the ball in one's hands, one sees fish after fish appear to infinity.

But is this spherical result really completely satisfying? Certainly not for a graphic artist, who is more bound to the *flat* surface than is a draftsman, painter, or sculptor. And even apart from this, twelve identical fish are not the same as infinitely many.

However, there are also other ways to represent an infinite number without bending the flat surface. *Smaller and Smaller I* (no. 6) is a first attempt in this direction. The figures with which this wood engraving is constructed reduce their surface area by half constantly and radially from the edges to the center, where the limit of the infinitely many and infinitely small is reached in a single point. But this configuration, too, remains a fragment, because it can be expanded as far as one wishes by adding increasingly larger figures.

The only way to escape this fragmentary character and to set an infinity in its entirety within a logical boundary line is to use the reverse of the approach in *Smaller and Smaller I*. The first, still awkward application of this method is shown by *Circle Limit I* (no. 163). The largest animal figures are now located in the center, and the limit of the infinitely many and infinitely small is reached at the circular edge. The skeleton of this configuration, apart from the three straight lines passing through the center, consists solely of arcs with increasingly shorter radii the closer they approach the limiting edge. In addition, they all intersect it at right angles. The woodcut *Circle Limit I*, being first, shows many deficiencies. Both the shape of the fish, still hardly developed from linear abstractions to rudimentary animals, and their arrangement and attitude with respect to each other, leave much to be desired. Accentuated by their backbones, which pass into each other longitudinally, series of fish can be recognized in alternating pairs— white ones with heads facing each other and black ones whose tails touch. Thus, there is no continuity, no one-way direction, no unity of color in each row.

In the colored woodcut *Circle Limit III* (no. 7) most of these defects have been eliminated. There are now only series moving in one direction: all the fish of the same series have the same color and swim after each other, head to tail, along a circular course from edge to edge. The more closely they approach the center, the larger they become. Four colors were required in order that each total series contrast with its surroundings.

No single component of all the series, which from infinitely far away rise like rockets perpendicularly from the limit and are at last lost in it, ever reaches the boundary line. Outside it, however, is the "absolute nothing." But the spherical world cannot exist without this emptiness around it, not only because "inside" presumes "outside" but also because in the "nothing" lie the strict, geometrically determined, immaterial middle points of the arcs of which the skeleton is constructed.

There is something in such laws that takes the breath away. They are not discoveries or inventions of the human mind, but exist independently of us. In a moment of clarity, one can at most discover that they are there and take them into account. Long before there were people on the earth, crystals were already growing in the earth's crust. On one day or another, a human being first came across such a sparkling morsel of regularity lying on the ground or hit one with his stone tool and it broke off and fell at his feet, and he picked it up and regarded it in his open hand, and he was amazed.

The Plates

This book includes the most important of Escher's prints. We have omitted the less important work to clarify the impression formed by the entire oeuvre. Drawings and studies, as well as objects, illustrations, and applied works, are also represented. The prints, drawings, and other works are given in exact chronological sequence, except for the colorplates and in occasional cases where early drawings, used later for a print, have been placed near the corresponding print.

Unless otherwise noted, all the works belong to the Escher Foundation, which has loaned its collection for an unlimited period to the Gemeentemuseum, The Hague. Signature and dating are mentioned only where they form part of the print. All sizes are given in millimeters and inches, and height precedes width.

The number of impressions in an edition of a print is not given because it is difficult to determine exactly how many were made—for many of the prints from the period after 1937 hundreds of impressions were made, whereas the early prints usually had between thirty and fifty impressions to an edition.

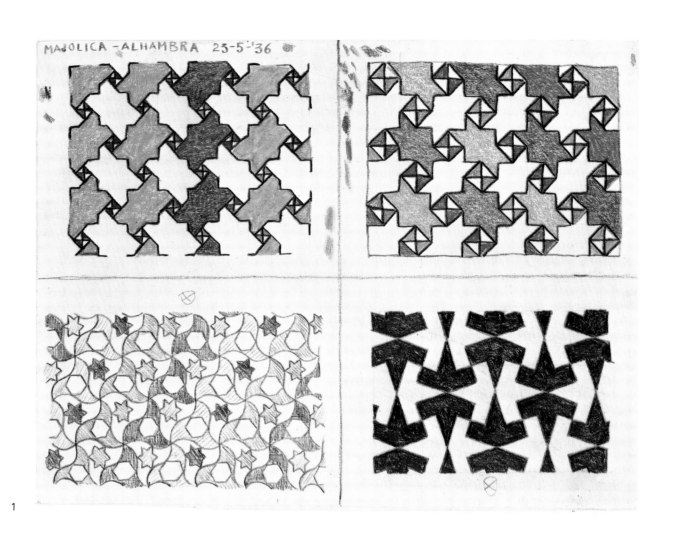

1

1. Copy of mosaics in the Alhambra. 1936
 Pencil and colored crayon, 239×318 ($9\frac{3}{8}$×$12\frac{1}{2}$'')
 Dated and inscribed: MAJOLICA- ALHAMBRA 23-5-'36

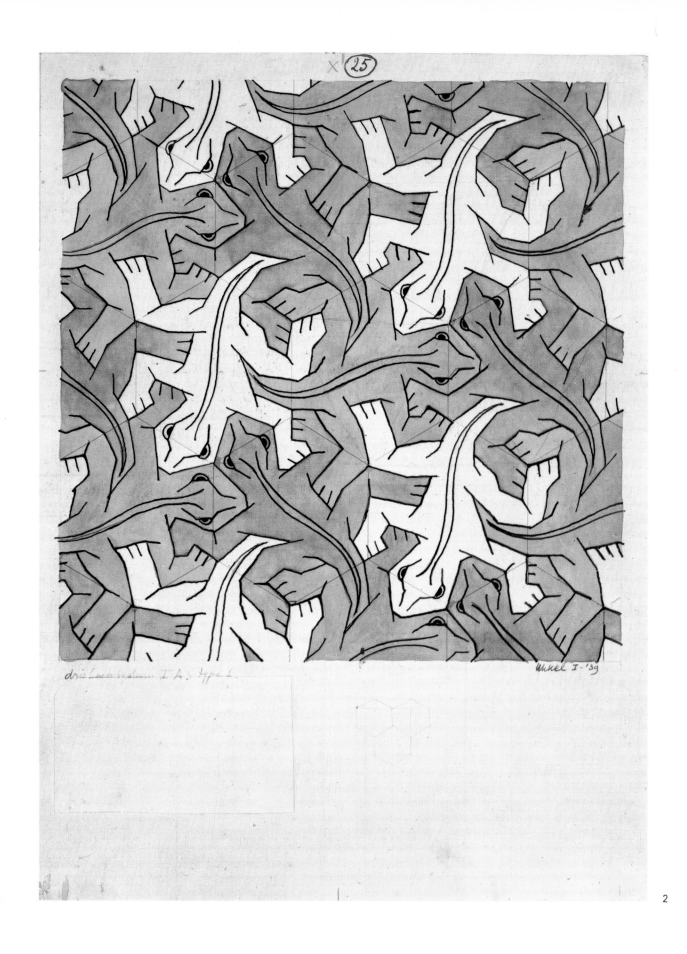

2. Study of Regular Division of the Plane with Reptiles. 1939
Pencil, india ink, and watercolor, 359×269 (14⅛×10⅝″)
Dated and inscribed: driehoek systeem I A3 type 1 Ukkel
I-'39 (used for the lithograph Reptiles, 1943, no. 102)

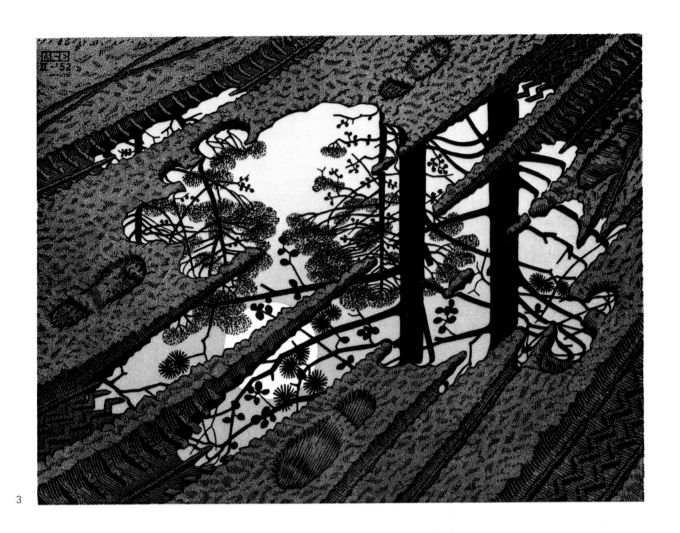

3

3. Puddle. 1952
 Woodcut in three colors, 240×323 (9½×12¾'')
 Signed and dated: MCE II-'52 (the woodcut Calvi Corsica,
 1933, is used for the reflecting trees, see no. 52)

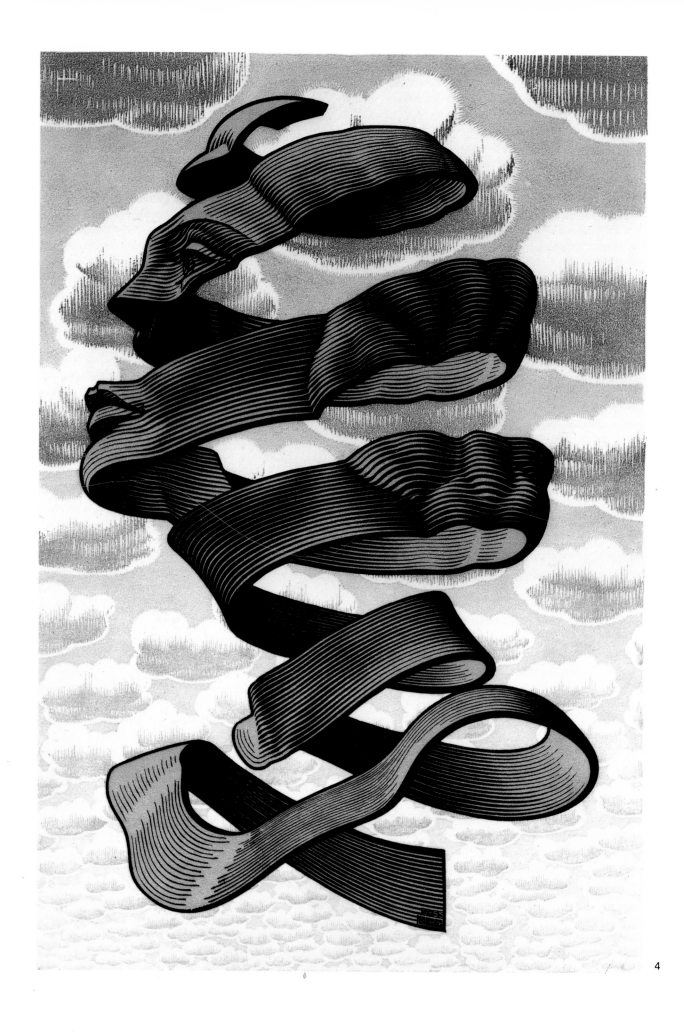

4

4. Rind. 1955
 Wood engraving in four colors, 345×235 (13⅝×9¼″)
 Signed and dated: V-55 MCE

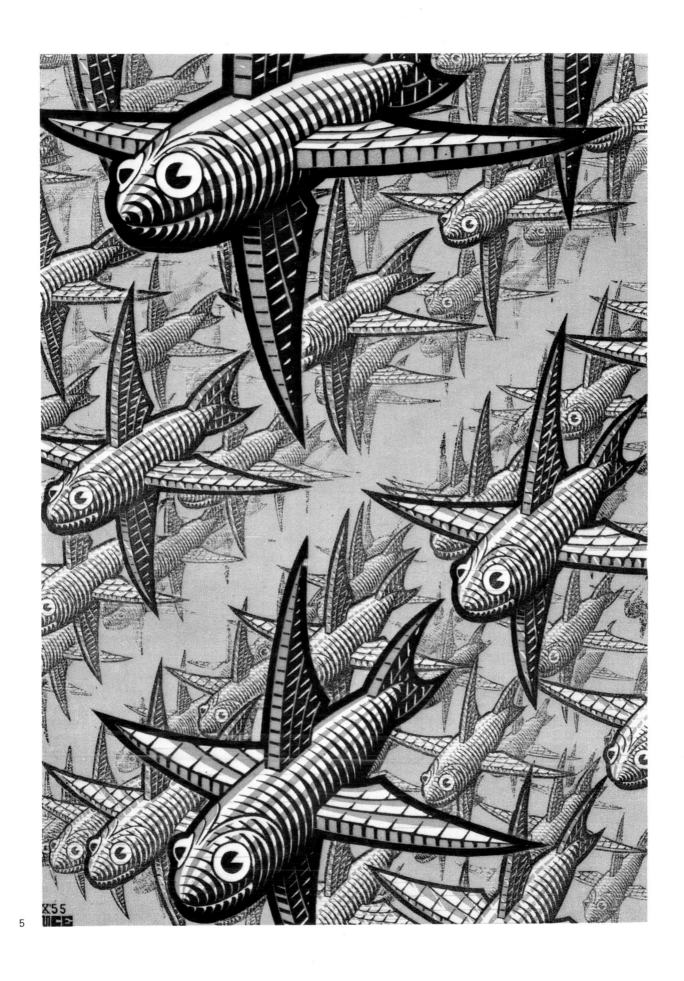

5

5. Depth. 1955
Wood engraving and woodcut in two colors, 320×230
(12⅝×9")
Signed and dated: X'55 MCE

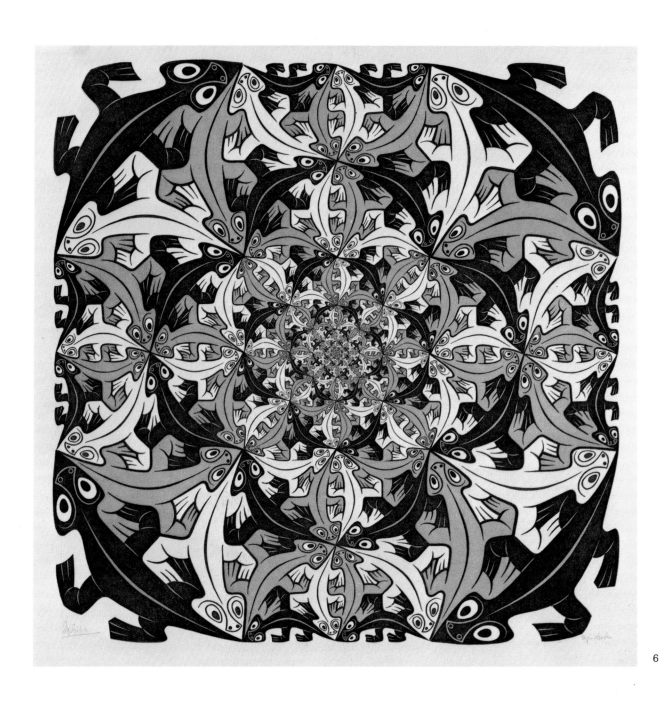

6

6. Smaller and Smaller I. 1956
 Wood engraving in two colors, 387×387 (15¼×15¼″)
 Signed and dated: MCE X-56

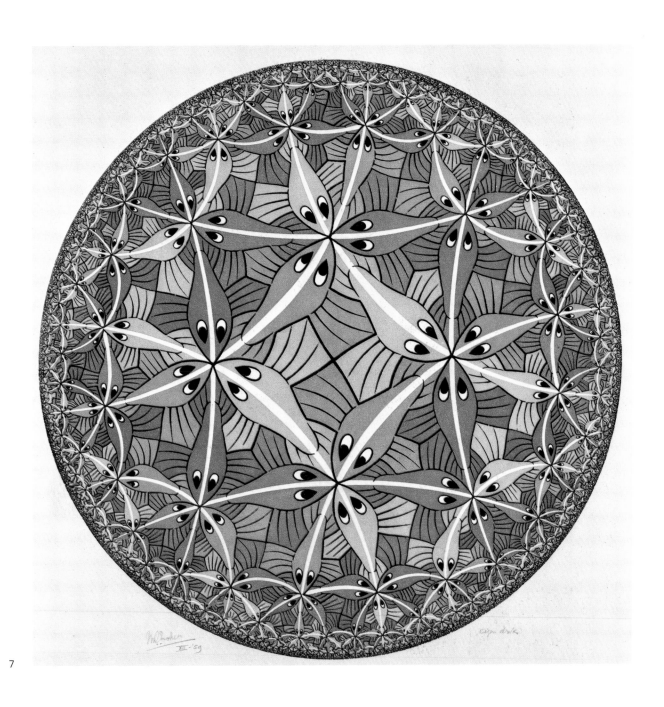

7

7. Circle Limit III. 1959
 Woodcut in five colors, diameter 415 (16$\frac{3}{8}$″)

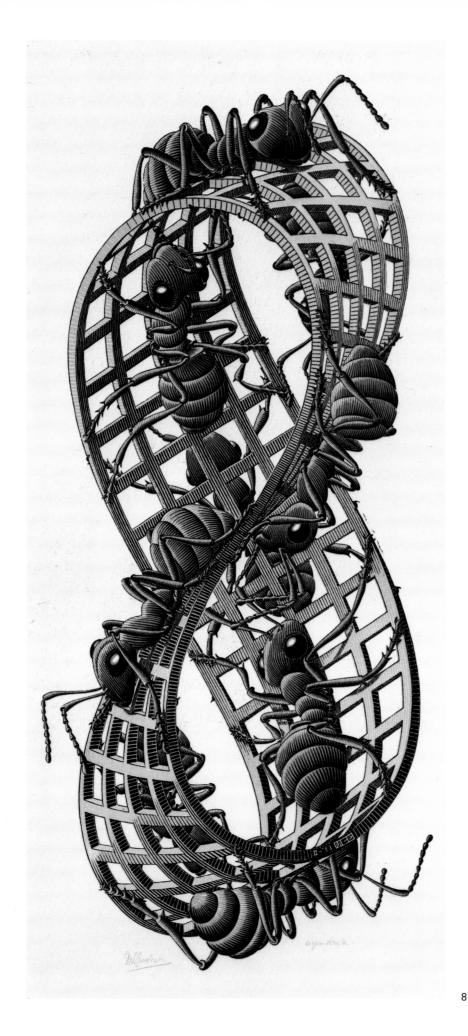

8

8. Moebius Strip II. 1963
 Wood engraving in three colors, 455×207 (17⅞×8⅛″)
 Signed and dated: II-'63 MCE

9

9. St. Bavo's, Haarlem. 1920
 India ink, 1170×990 (46⅛×39″)
 Signed and dated: MCE '20

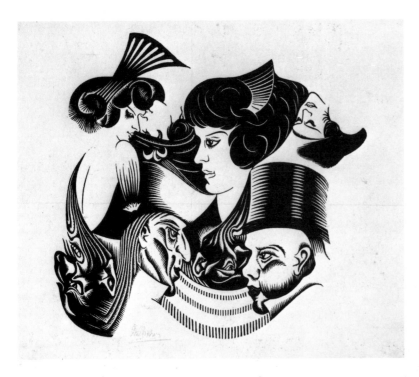

10

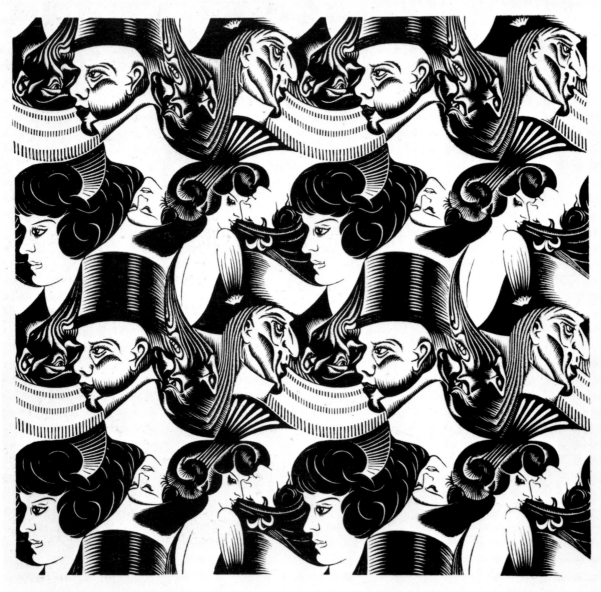

11

10. Basic motif used for the woodcut "Eight Heads." 1922
 Woodcut, 190×204 (7½×8")

11. Eight Heads. 1922
 Woodcut, 325×340 (12¾×18⅜")

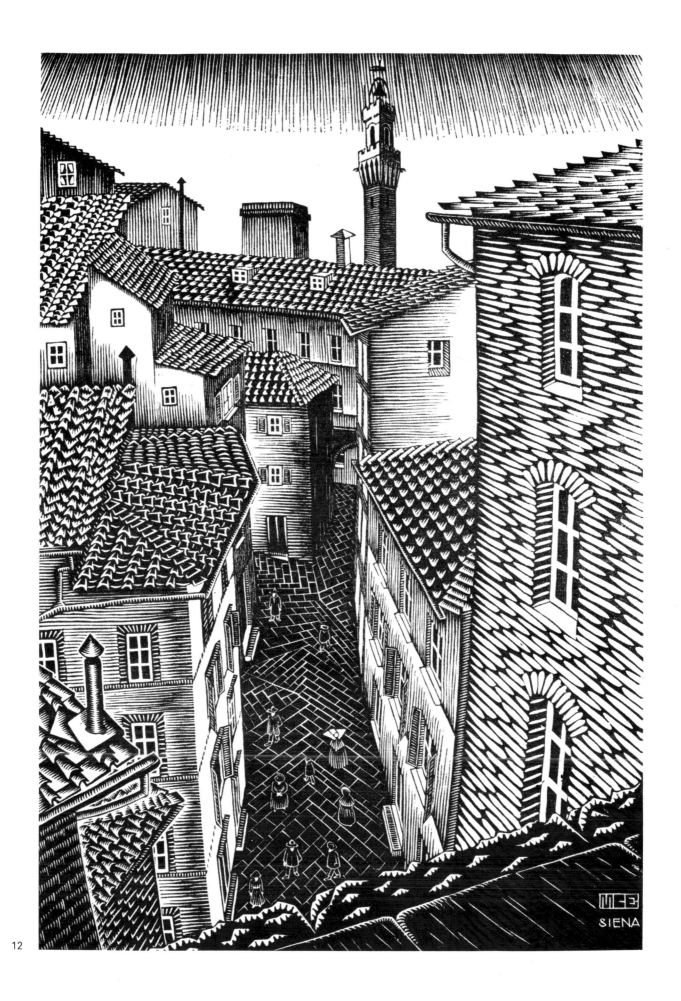

12

12. Siena. 1922
Woodcut, 323×220 (12¾×8⅝″)
Signed: MCE SIENA

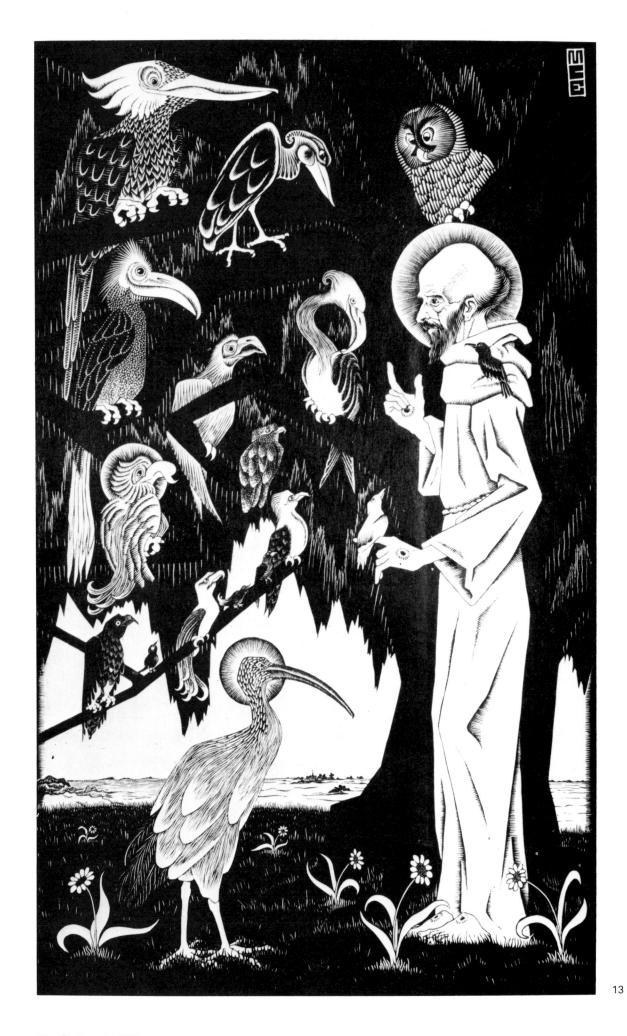

13

13. St. Francis. 1922
Woodcut, 507 x 307 (20 x 12⅛'')
Signed: MCE

14

15

14. San Gimignano. 1922
Woodcut, 247×321 (9¾×12⅝″)
Signed and dated: MCE '22

15. San Gimignano. 1923
Woodcut, 290×429 (11⅜×19⅜″)
Signed and dated: MCE '23

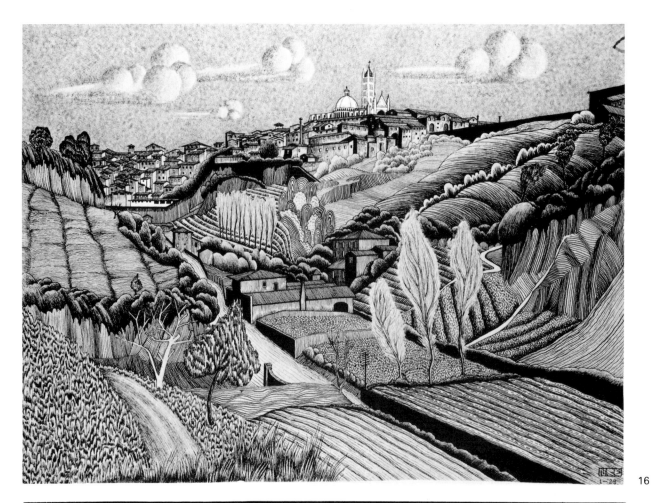

16

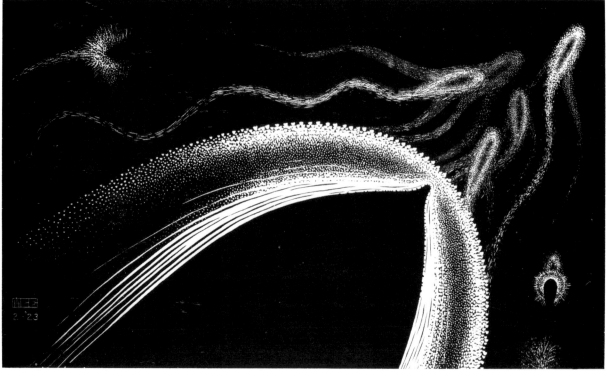

17

16. Italian Landscape. 1923
India ink and white gouache, 395×541 (15½×21¼'')
Signed and dated: MCE 1-'23

17. Dolphins in Phosphorescent Sea. 1923
Woodcut, 290×492 (11⅜×19⅜'')
Signed and dated: MCE 2-'23

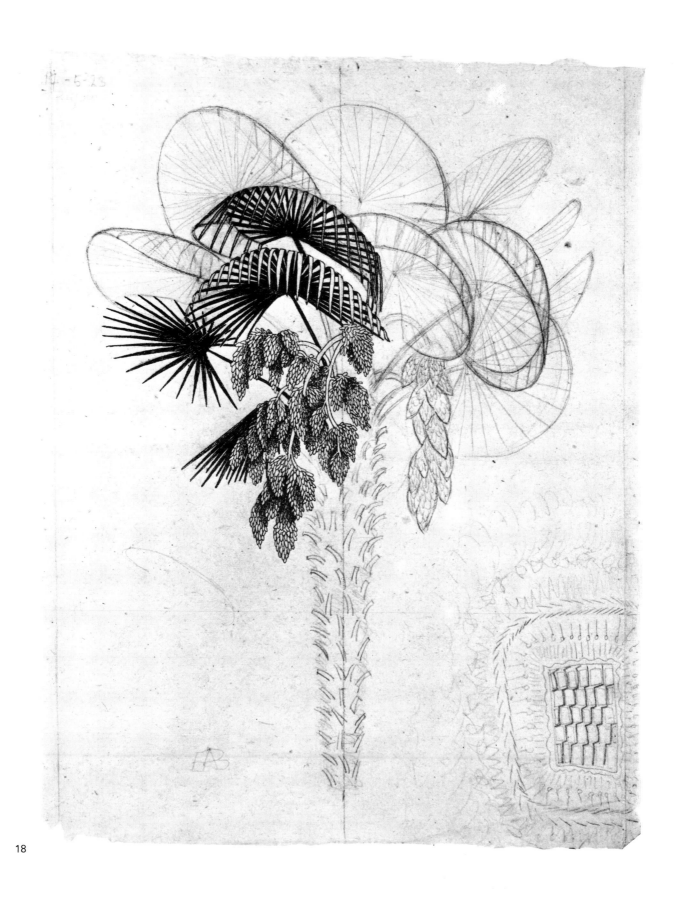

18

18. Palm Tree. 1923
Pencil and india ink, 385×300 (15⅛×11¾'')
Dated: 17-5-'23 RUFOLO

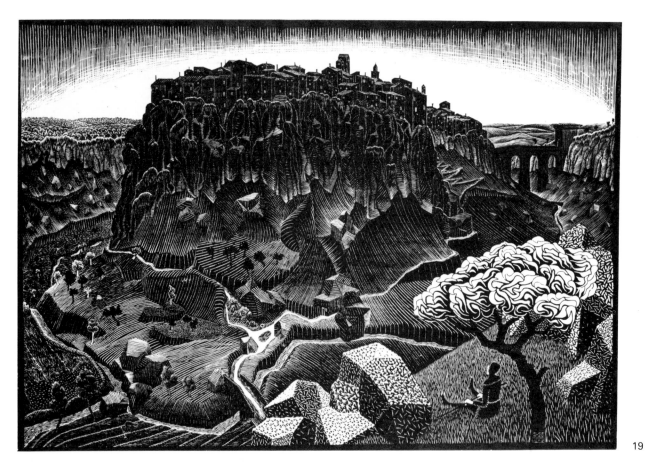

19

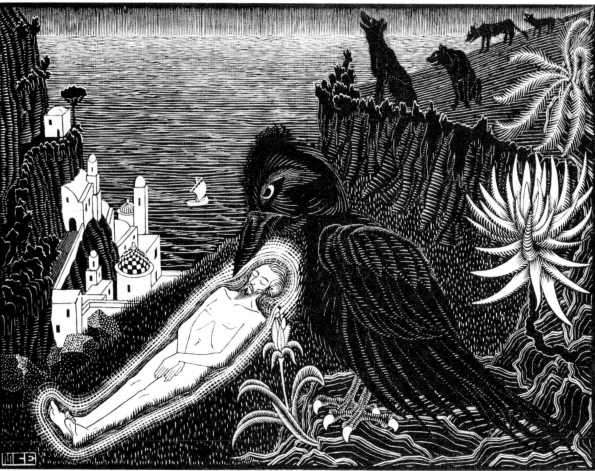

20

19. Vitorchiano. 1925
 Woodcut, 391×570 (15⅜×22½")
 Signed and dated: 2-25 MCE

20. The Black Raven. 1925
 Woodcut, 209×282 (8¼×11⅛")
 Signed: MCE

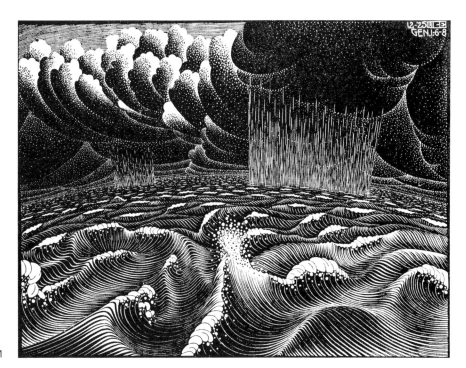

21

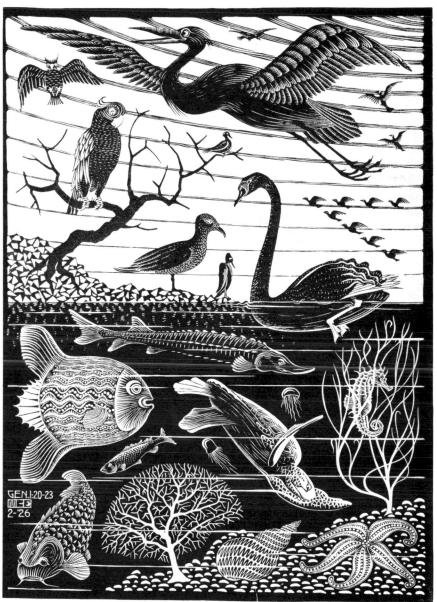

22

21. The Second Day of the Creation. 1925
 Woodcut, 279×374 (11×14¾″)
 Signed, dated, and inscribed: 12-'25 MCE GEN. 1 : 6-8

22. The Fifth Day of the Creation. 1926
 Woodcut, 375×285 (14¾×11¼″)
 Signed, dated, and inscribed: GEN. 1 : 20-23 MCE 2-'26

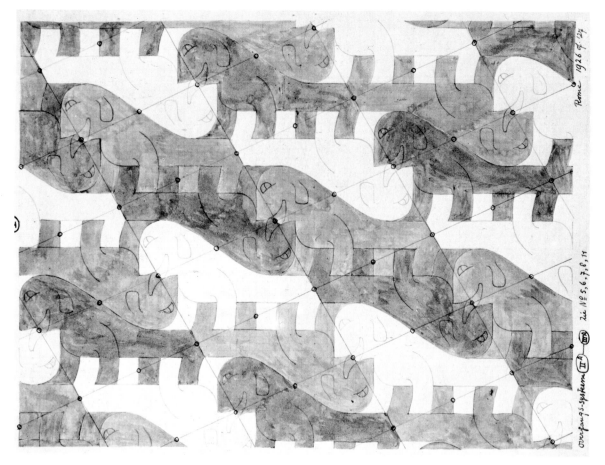

23

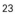

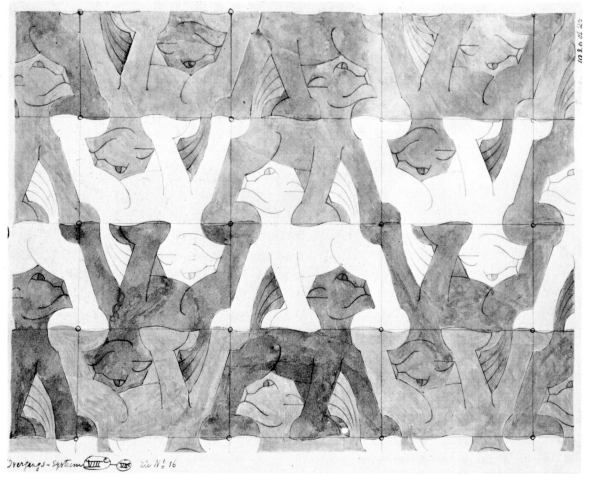

24

23. Study of regular division of the plane with imaginary
animals. 1926 or 1927
Pencil and watercolor in red and green, 270×358
(10⅝×14⅛'')
Dated and inscribed: Overgangs-systeem IIA-IIIA Rome
1926 of 27 (inscription presumably added after 1936)

24. Study of regular division of the plane with imaginary
animals. 1926 or 1927
Pencil and watercolor in red and green, 270×355
(10⅝×14'')
Dated and inscribed: Overgangs-systeem VIIIC-VIIC Rome
1926 of 27 (inscription presumably added after 1936)

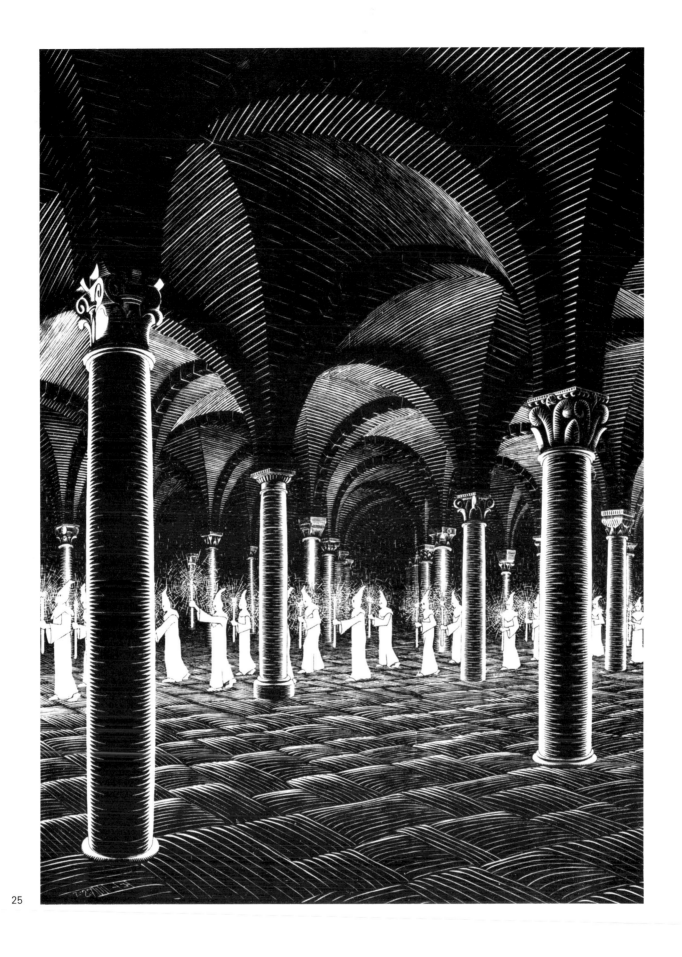

25

25. Procession in Crypt. 1927
Woodcut, 605×441 (23⅞×17⅜'')
Signed and dated: 7-'27 MCE

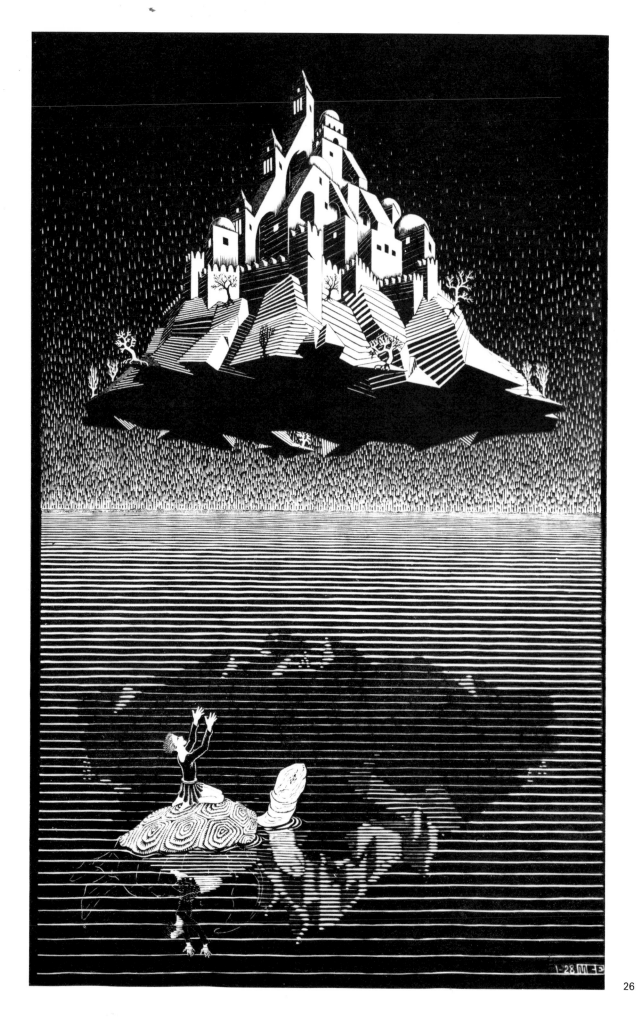

26. Castle in the Air. 1928
 Woodcut, 625×387 (24⅝×15¼'')
 Signed and dated: 1-'28 MCE

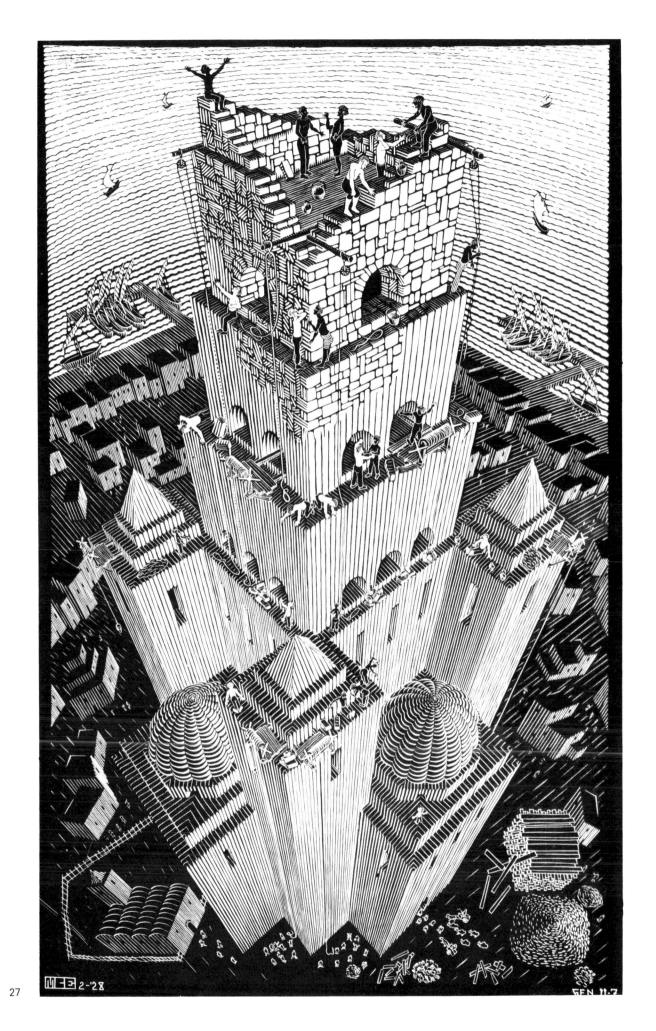

27

27. Tower of Babel. 1928
Woodcut, 622×386 (24½×15¼'')
Signed, dated, and inscribed: MCE 2-'28 GEN. 11 : 7

28

29

28. Corte Corsica. 1928
India ink, stencil technique,
515×645 (20¼×25⅜'')
Signed, dated, and
inscribed: MCE CORTE
CORSICA 7-'28

29. Sartene. 1928
India ink, 650×500
(25⅝×19⅝'')
Signed, dated, and
inscribed: MCE SARTENE
8-'28

30. Soveria, Corsica. 1928
India ink, stencil technique,
505×655 (19⅞×25¾'')
Signed, dated, and
inscribed: SOVERIA
CORSICA MCE 9-'28

31. Bonifacio, Corsica. 1928
Woodcut, 710×412
(28×16¼'')
Signed and dated: 10-'28
MCE

32. The Drowned Cathedral.
1929
Woodcut, 721×415
(28¾×16⅜'')
Signed and dated: 1-'29
MCE

30

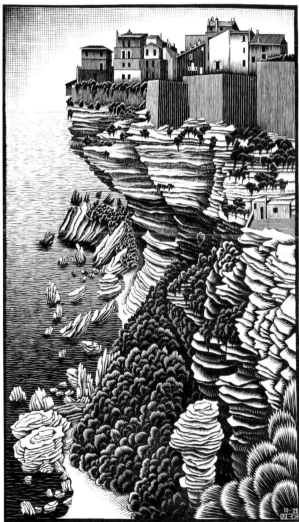

31/32

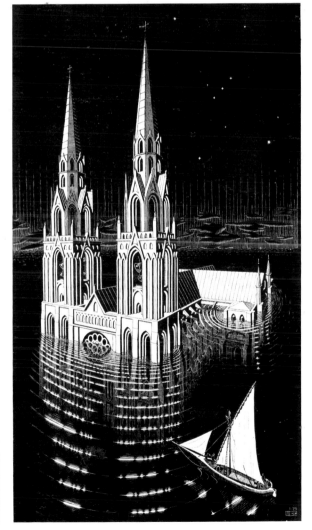

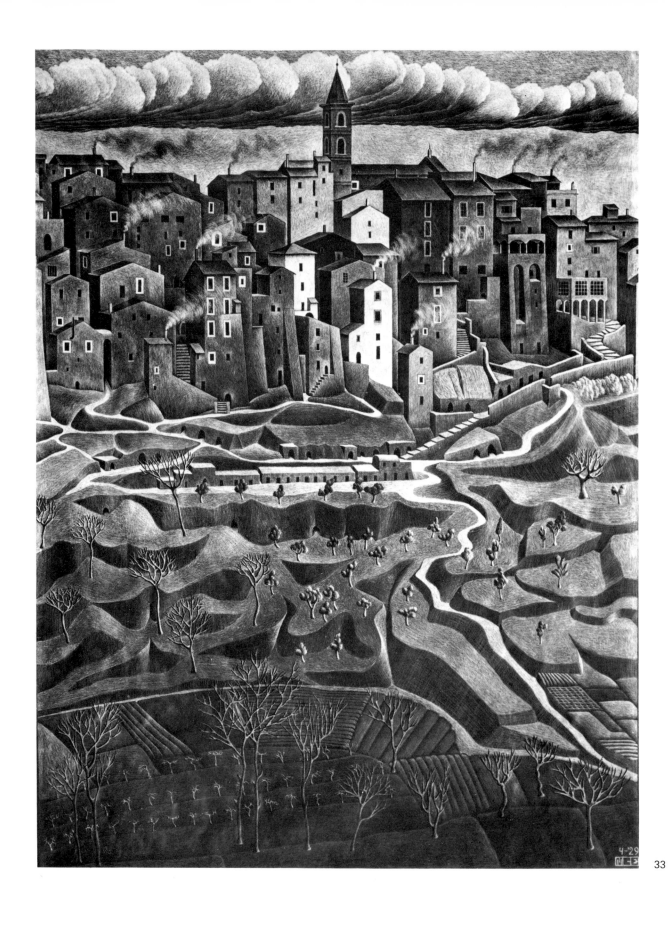

33

33. Genazzano, Abruzzi. 1929
 Lithographic ink ("scratch" drawing), 604×458 (23¾×18")
 Signed and dated: 4-'29 MCE

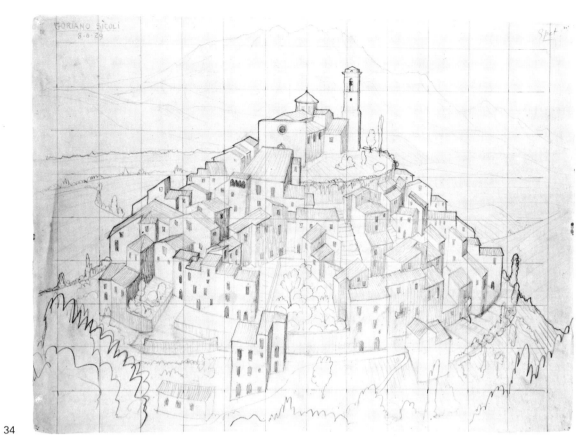

34

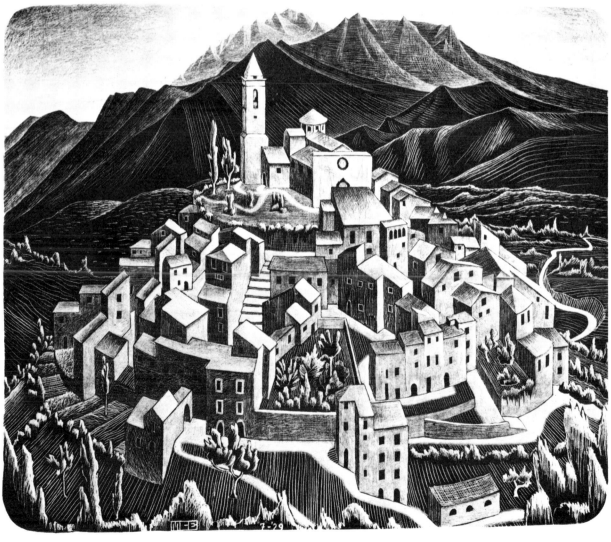

35

34. Study for the lithograph "Goriano Sicoli, Abruzzi." 1929
 Pencil, 480×660 (18⅞×26")
 Dated and inscribed: GORIANO SICOLI 8-6-'29

35. Goriano Sicoli, Abruzzi. 1929
 Lithograph, 239×289 (9⅜×11⅜")
 Signed and dated: MCE 7-'29

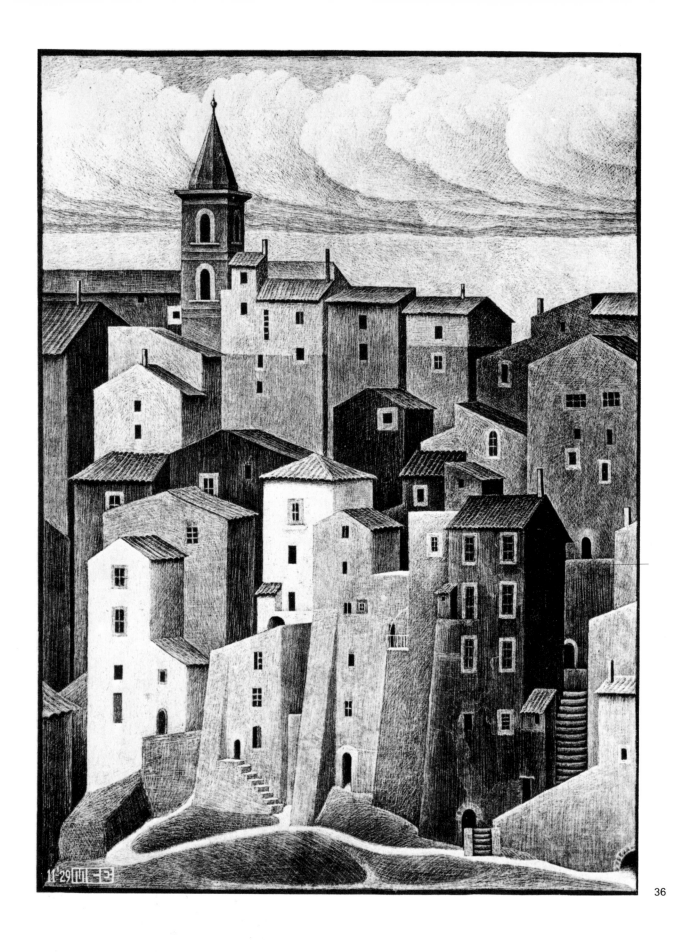

36

36. Genazzano, Abruzzi. 1929
 Lithograph (based on Genazzano, Abruzzi, 1929, see
 no. 33), 270 x 197 (10⅝ x 7¾'')
 Signed and dated: 11-'29 MCE

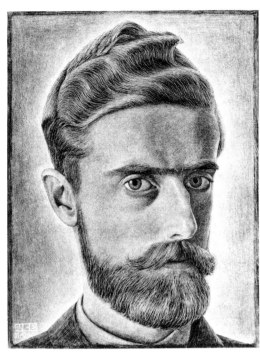

37

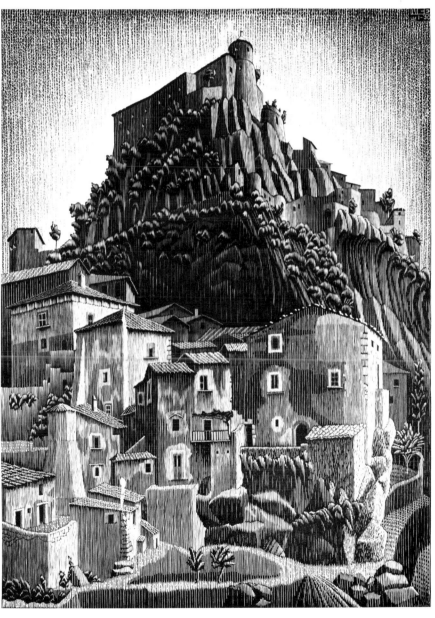

38

37. Self-Portrait. 1929
 Lithograph, 262×203 (10⅜×8″)
 Signed and dated: MCE 11-'29

38. Town in Southern Italy. 1930
 Woodcut, 650×480 (25⅝×18⅞″)
 Signed and dated: MCE 1-'30

43

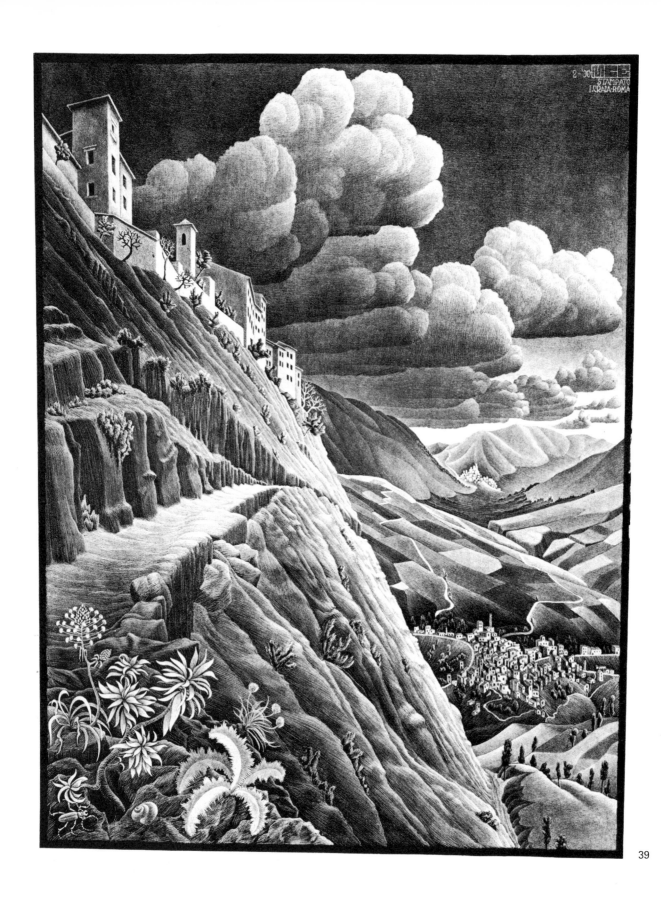

39

39. Castrovalva. 1930
Lithograph, 536×417 (21⅛×16⅜")
Signed, dated, and inscribed: 2-'30 MCE STAMPATO
I.CRAIA.ROMA

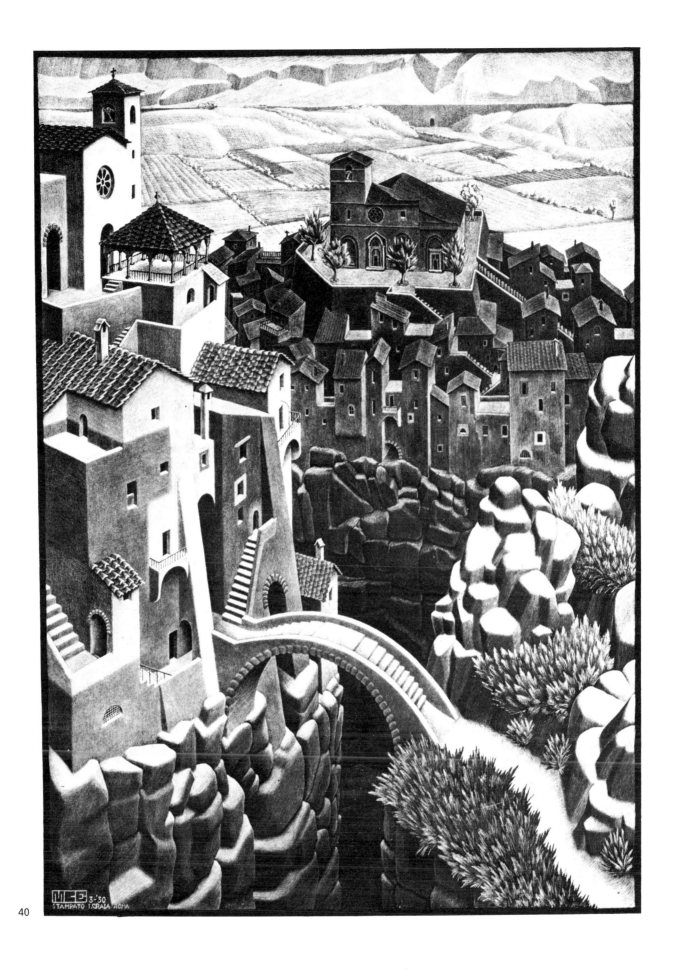

40.

40. Town in Southern Italy. 1930
Lithograph, 535×375 (21×14¾'')
Signed, dated, and inscribed: MCE 3-'30 STAMPATO
I.CRAIA ROMA

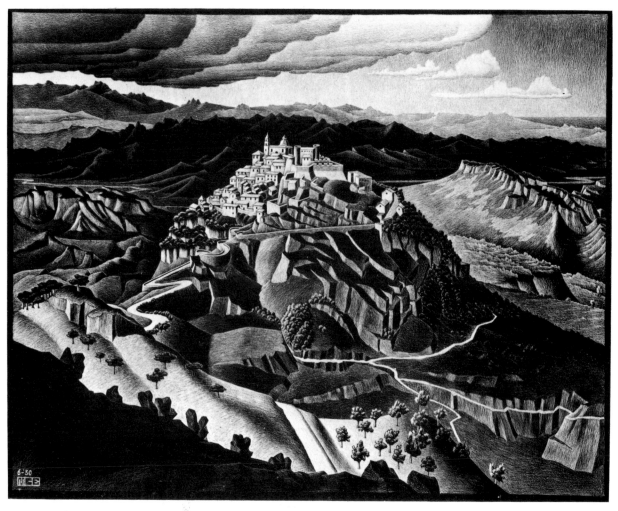

41

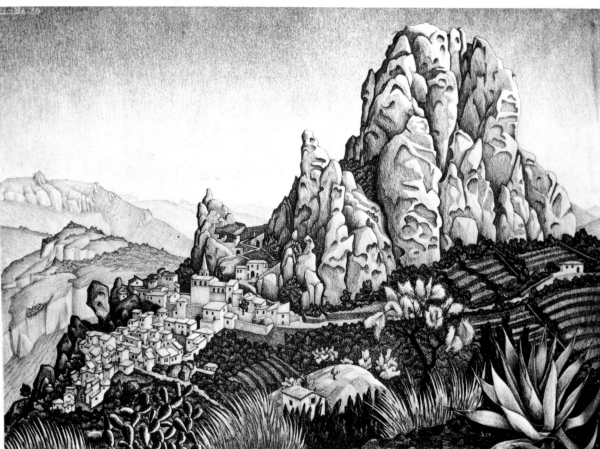

42

41. Italian Town. 1930
 Lithographic ink ("scratch" drawing), 442×568 (17⅜×22⅜'')
 Signed and dated: 6-'30 MCE
 Collection G. W. Locher, Leiden

42. Italian Town. 1930
 Lithographic crayon, 494×647 (19½×25½'')
 Signed and dated: MCE 6-'30

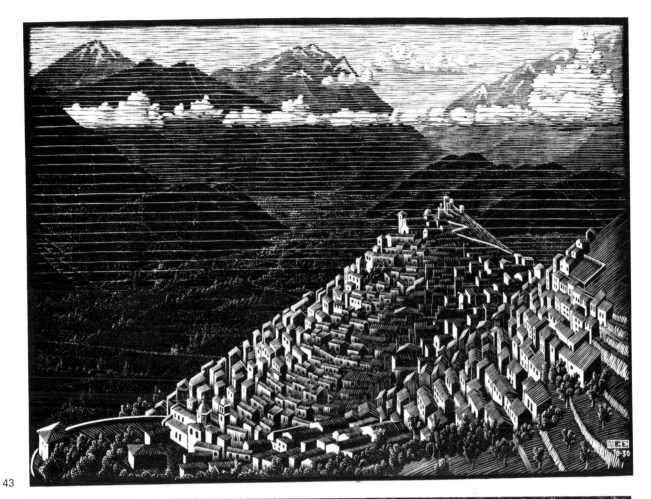

43

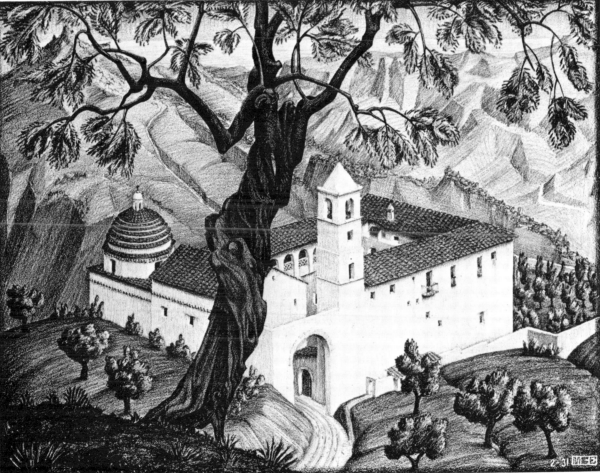

44

43. Morano, Calabria. 1930
 Woodcut, 240×322 (19½×12⅝'')
 Signed and dated: MCE 10-30

44. Rocca Imperiale, Calabria. 1931
 Lithograph, 230×305 (9×12'')
 Signed and dated: 2-'31 MCE

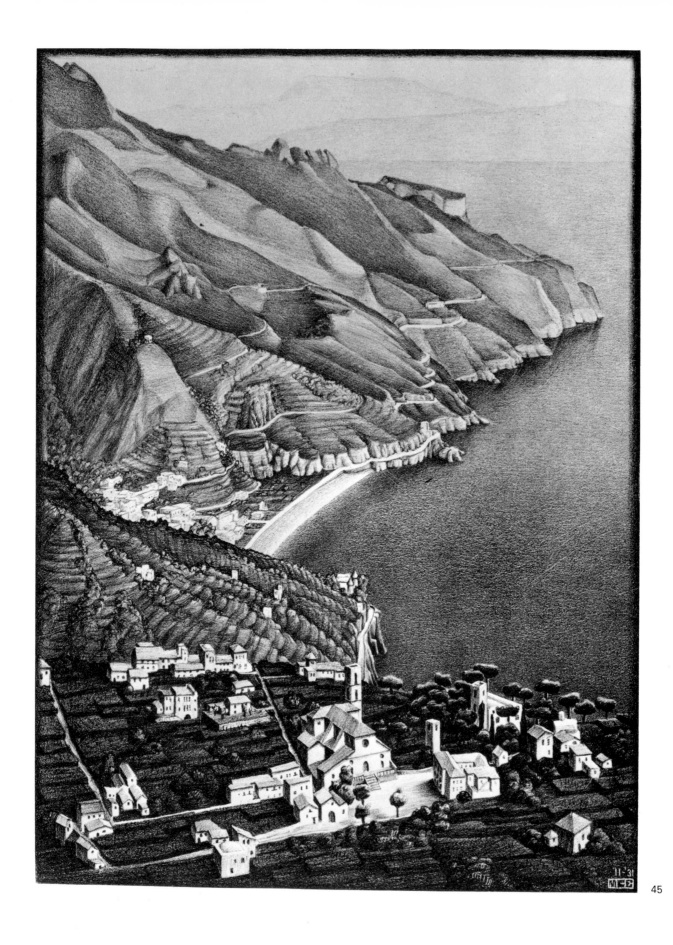

45

45. Coast of Amalfi. 1931
 Lithograph, 313×236 (12¾×9¼″)
 Signed and dated: 11-'31 MCE

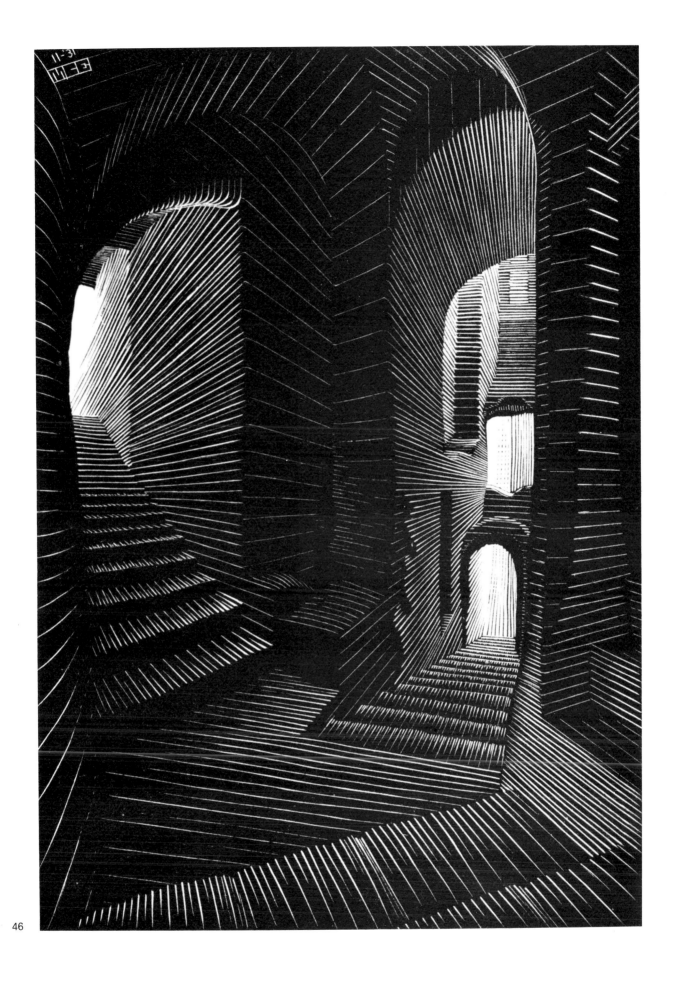

46

46. Vaulted Staircase. 1931
 Wood engraving, 179×129 (7×15⅛")
 Signed and dated: 11-'31 MCE

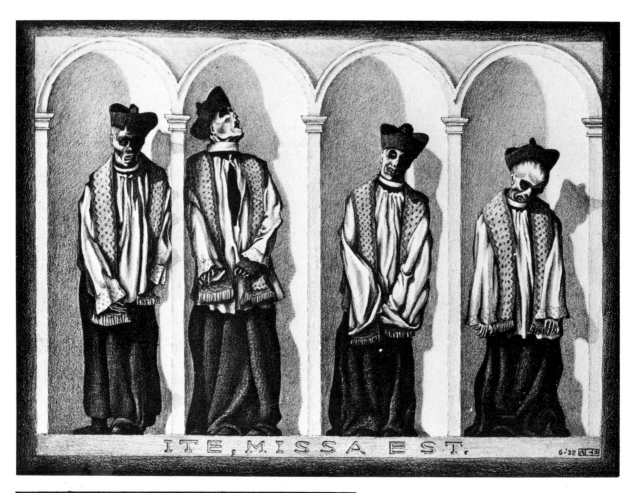

47

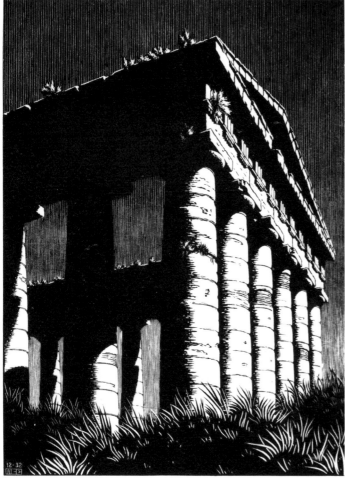

48

47. Mummified Bodies in Church in Southern Italy. 1932
 Lithograph, 204×273 (8×10¾'')
 Signed and dated: 6-'32 MCE

48. Temple of Segeste, Sicily. 1932
 Wood engraving, 322×242 (12⅝×9½'')
 Signed and dated: 12-32 MCE

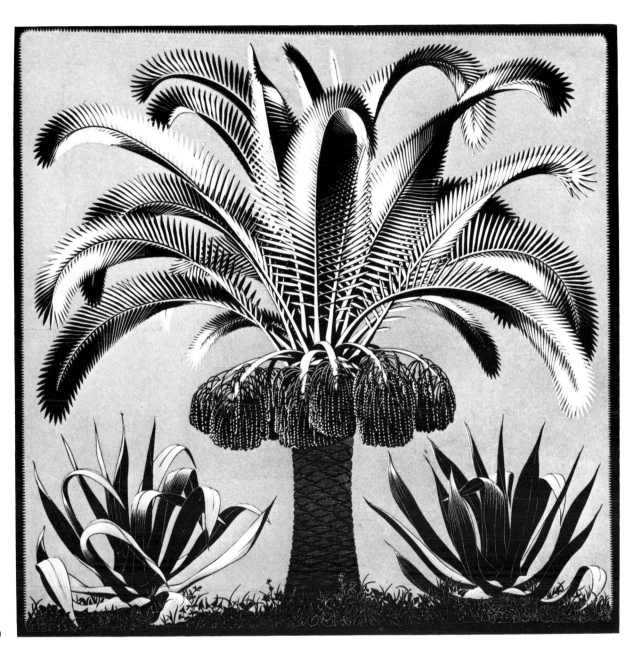

49

49. Palm. 1933
 Wood engraving in two colors, 397×397 (15$\frac{5}{8}$×15$\frac{5}{8}$″)
 Signed and dated: MCE 2-33

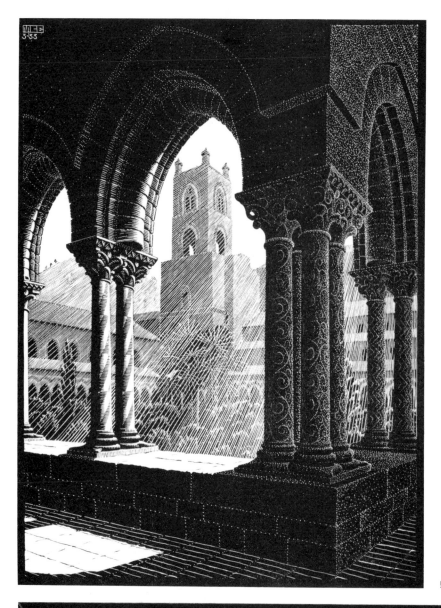

50

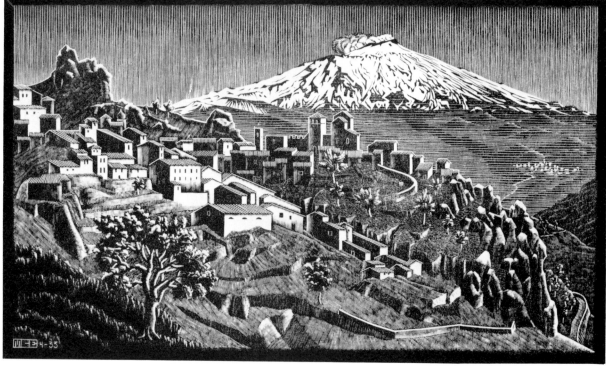

51

50. Chiostro di Monreale, Sicily. 1933
 Wood engraving, 320×240 (12⅝×9½″)
 Signed and dated: MCE 3-'33

51. Sicily. 1933
 Wood engraving, 190×319 (7½×12⅝″)
 Signed and dated: MCE 4-33

52

53

52. Calvi, Corsica. 1933
 Woodcut in three colors, 355×470 (13⅞×18½'')
 Signed and dated: 6-'33 MCE (top half used for the
 woodcut Puddle, 1952, no. 3)

53. Phosphorescent Sea. 1933
 Lithograph, 330×245 (13×9⅝'')
 Signed and dated: MCE 7-'33

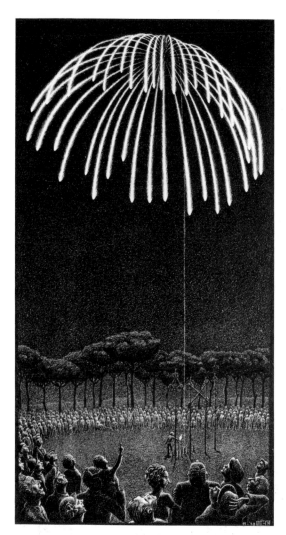

54. Fireworks. 1933
 Lithograph, 424×226 (16¾×8⅞")
 Signed and dated: 11-'33 MCE

55. Calanche, Corsica. 1934
 Lithograph, 308×207 (12⅛×8⅛")
 Signed and dated: MCE 1-'34

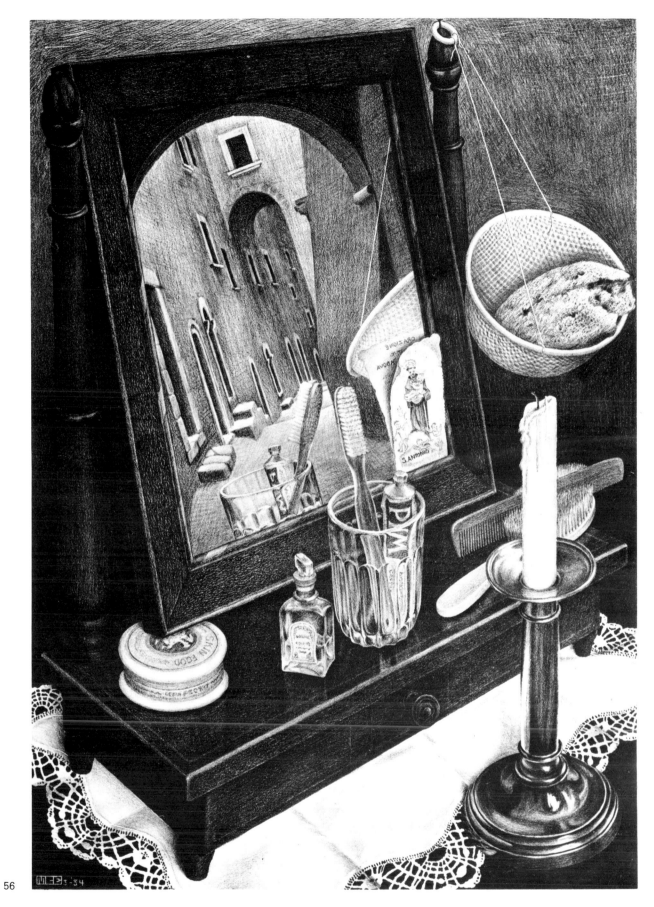

56

56. *Still Life with Mirror.* 1934
 Lithograph, 394 x 288 (15½ x 11⅜'')
 Signed and dated: MCE 3-'34

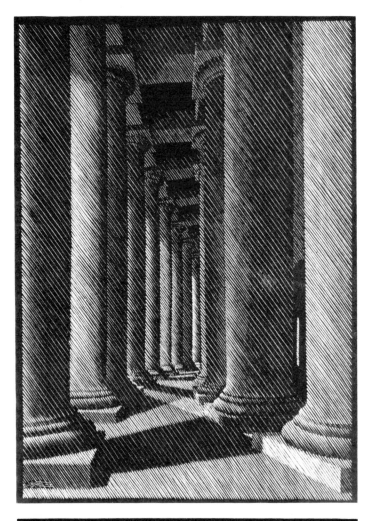

57

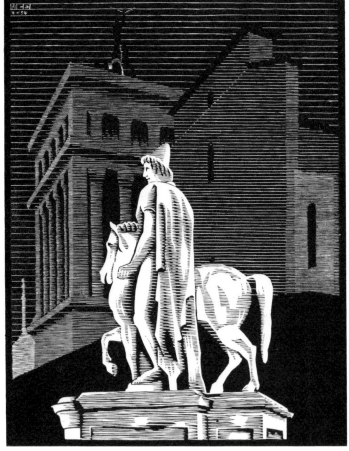

58

57. Colonnade of St. Peter's in Rome. 1934
Woodcut, 310×229 (12¼×9")
Signed and dated: 3-34 MCE

58. Nocturnal Rome: The Capitoline Hill, Square of "Dioscuro Pollux." 1934
Woodcut, 298×238 (11¾×9⅜")
Signed and dated: MCE 4-'34

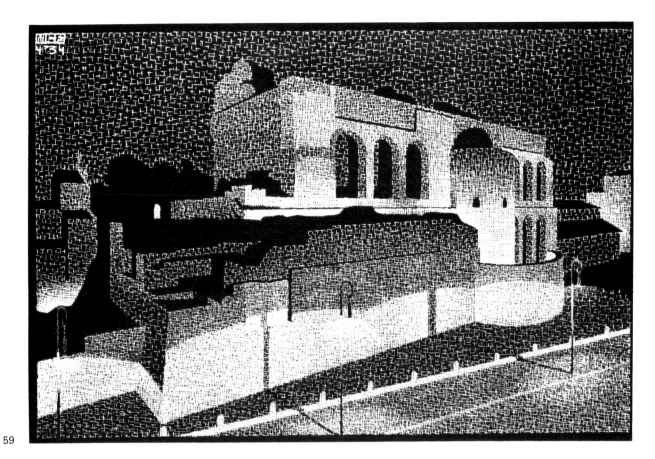

59

60

59. Nocturnal Rome: Basilica di Massenzio. 1934
 Woodcut, 210×309 (8¼×12⅛'')
 Signed and dated: MCE 4-34

60. Old Houses in Positano. 1934
 Lithograph, 272×297 (10¾×11¾'')
 Signed and dated: MCE 8-34

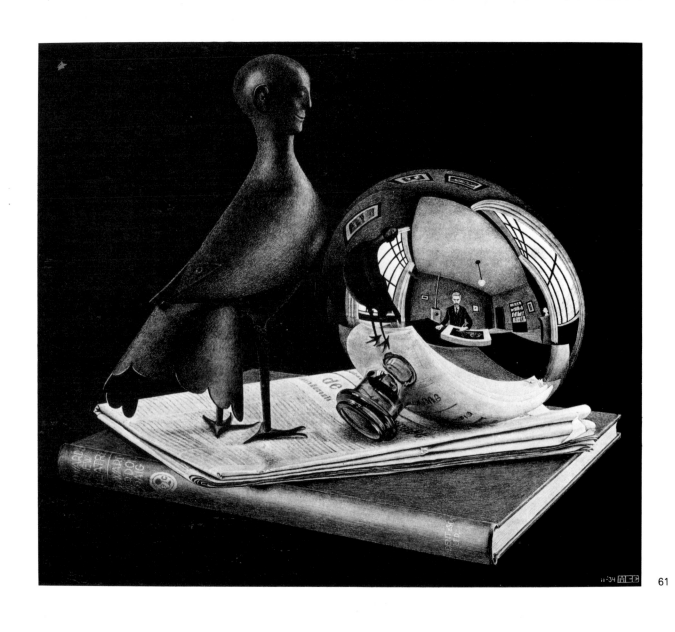

61. Still Life with Reflecting Sphere. 1934
 Lithograph, 286×326 (11¼×12⅞'')
 Signed and dated: 11-'34 MCE

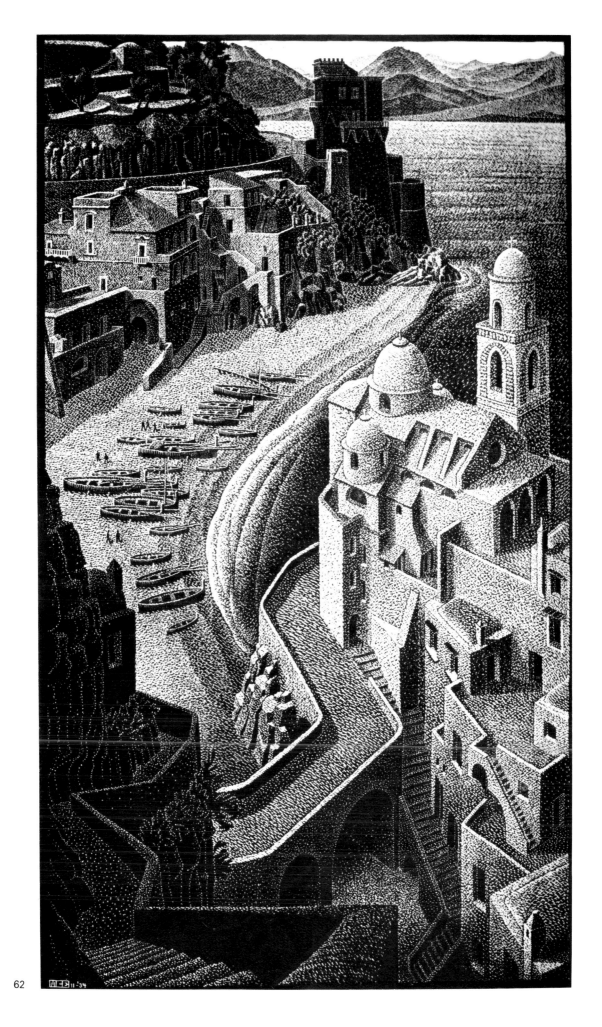

62. Coast of Amalfi. 1934
 Woodcut, 695×407 (27⅜×16″)
 Signed and dated: MCE 11-'34

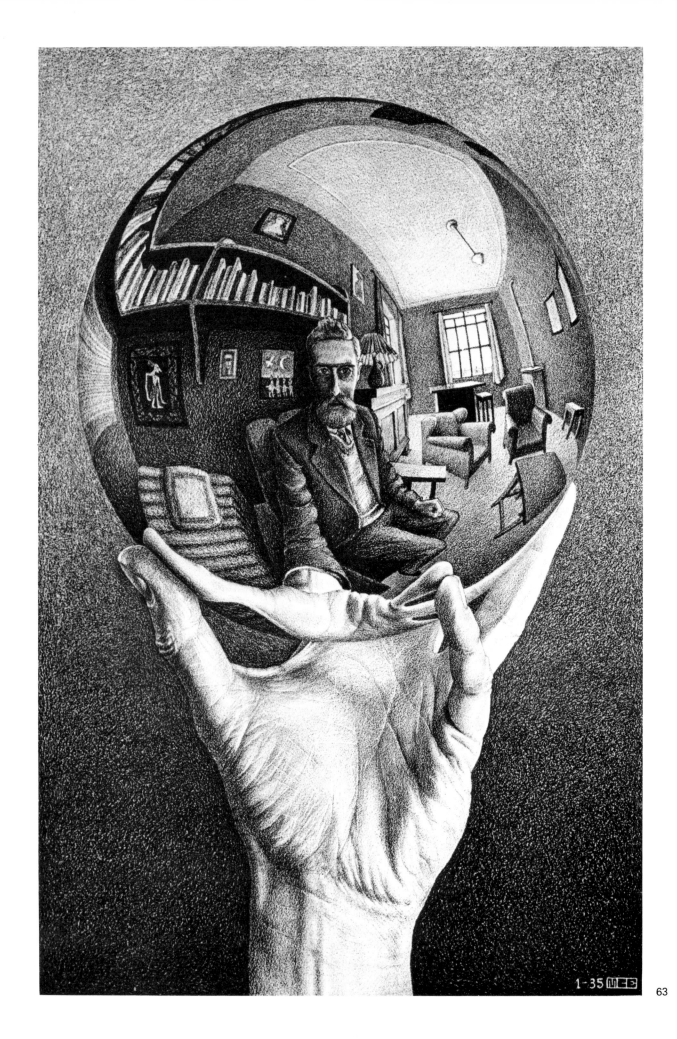

63. Hand with Reflecting Sphere. 1935
Lithograph, 318×214 (12½×8⅜″)
Signed and dated: 1-35 MCE

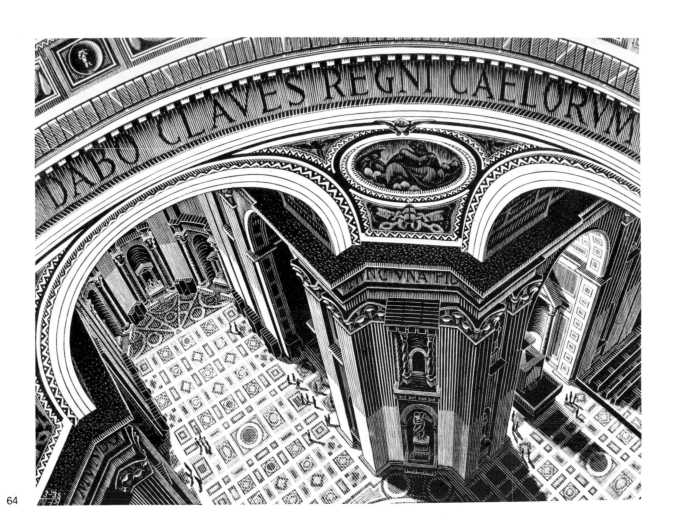

64

64. St. Peter's Rome. 1935
Wood engraving, 237×316 (9⅜×12½'')
Signed and dated: 3-'35 MCE

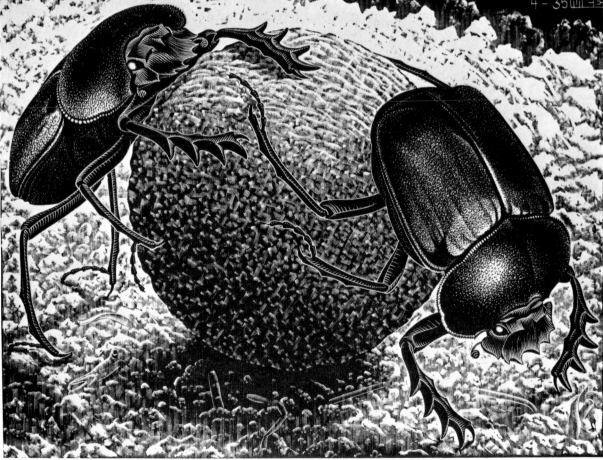

65. Grasshopper. 1935
Wood engraving, 182×243 (17¼×9⅝″)
Signed and dated: 3-'35 MCE

66. Scarabs. 1935
Wood engraving, 180×240 (7⅛×9½″)
Signed and dated: 4-'35 MCE

CAVALLO DI
S. GIORGIO

PENTEDATTILO
6-5-'30

Mantide (Mantis religiosa)
(Fangheuschrecken, Gottes aubeterinnen)

67

67. Study of praying mantis. 1930
Pencil, 315×240 (12⅜×9½'')
Dated: Pentedattilo 6-5-'30 (used for the wood engraving
Dream, 1935, no. 70)

68

69

68. Sante Maria dell'Ospedale, Ravello. 1931
Black and white crayons, 235×315 (9¼×12⅜″)
Dated and inscribed: S.M. d. Ospedale RAVELLO 9-5-31
(used for the wood engraving Dream, 1935, no. 70)

69. Study of a Bishop's Tomb. c. 1935
Black and white crayons, 240×320 (9½×12⅝″) (used for the
wood engraving Dream, 1935, no. 70)

64

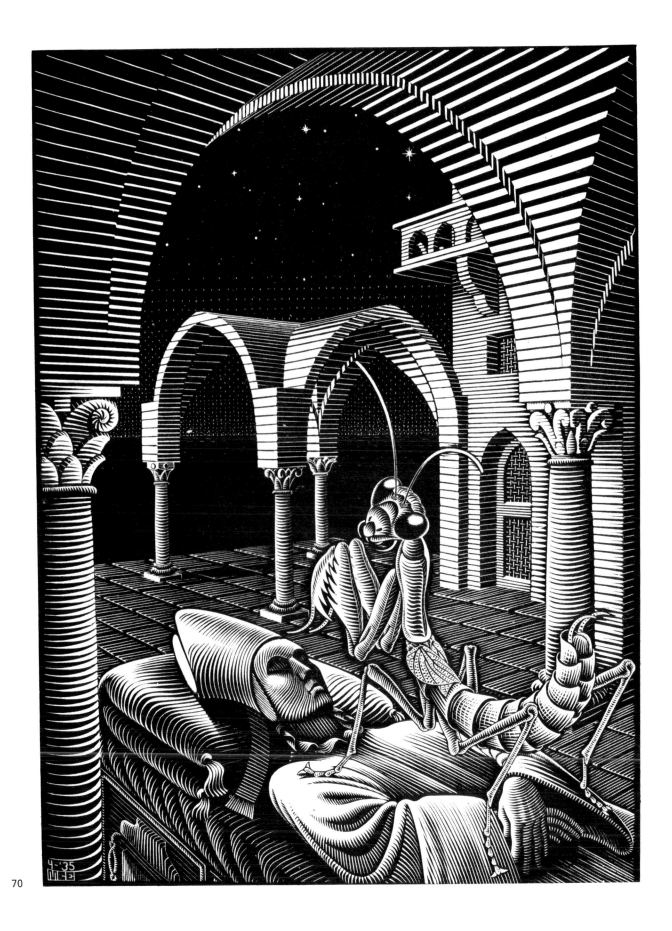

70

70. Dream. 1935
Wood engraving, 320×240 (12⅝×9½'')
Signed and dated: 4-'35 MCE

71

71. Portrait of G.A. Escher (father of the artist). 1935
 Lithograph, 236×208 (9¼×8¼'')
 Signed, dated, and inscribed: MCE 8-'35 G.A. Escher

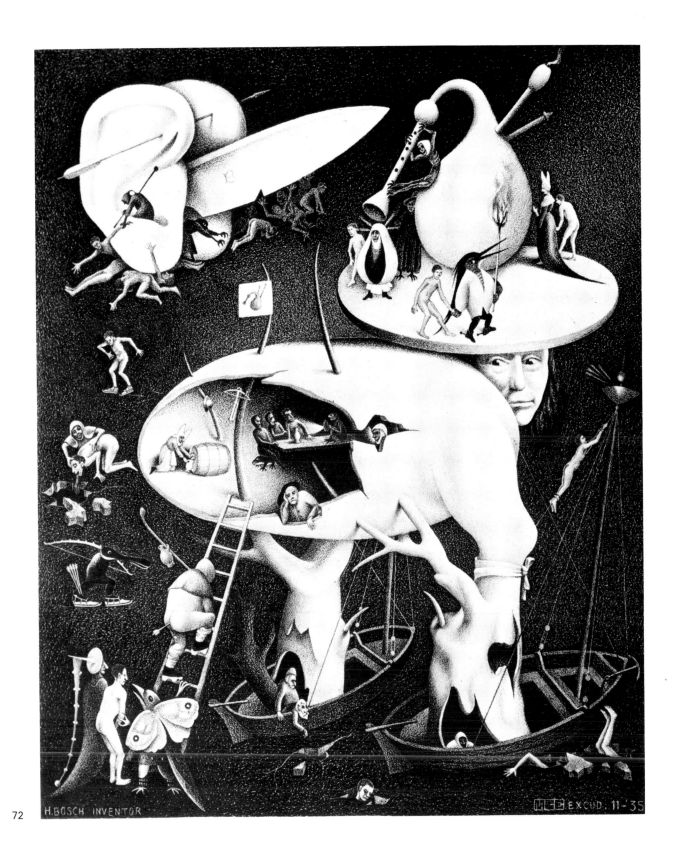

72

H. BOSCH INVENTOR

MCE EXCUD. 11-'35

72. Copy of a detail of the painting "The Garden of Delights"
 by Hieronymus Bosch. 1935
 Lithograph, 250×210 (9⅞×8¼'')
 Signed, dated, and inscribed: H. Bosch inventor MCE
 Excud. 11-'35

73

73. Snow in Switzerland. 1936
Lithograph, 340×280 (13⅜×11")
Signed and dated: MCE 1-'36

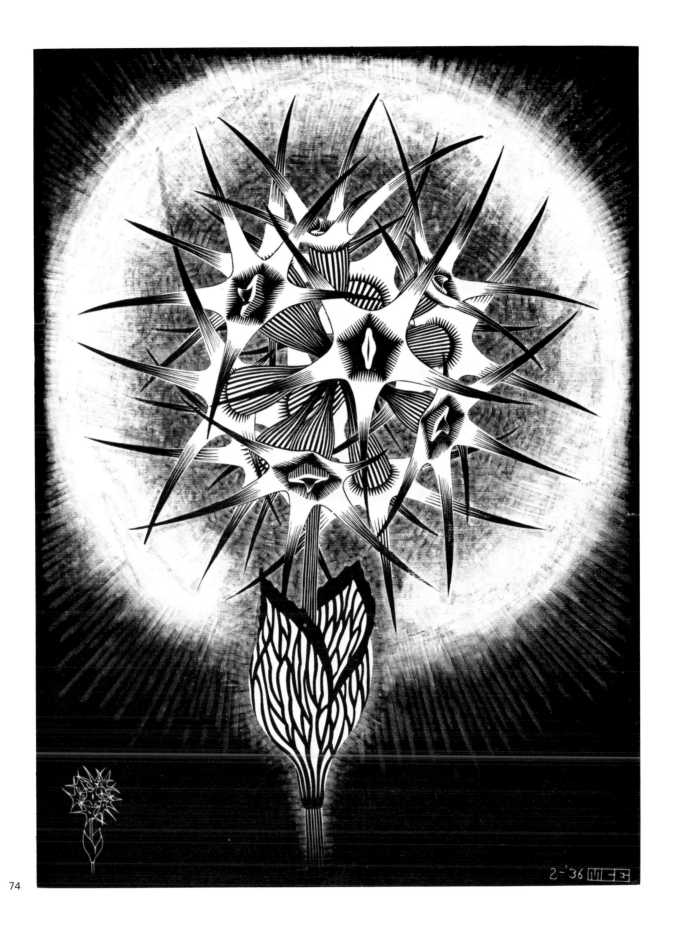

74

74. Prickly Flower. 1936
Wood engraving, 277×208 (10⅞×8¼'')
Signed and dated: 2-'36 MCE

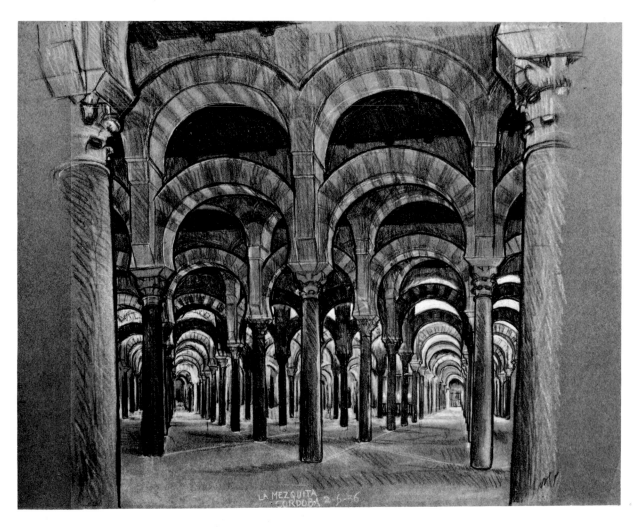

75

75. La Mezquita, Córdoba. 1936
Black and white crayons, 480×625 (18$\frac{7}{8}$×24$\frac{5}{8}$'')
Dated and inscribed: LA MEZQUITA CORDOBA 2-6-'36

70

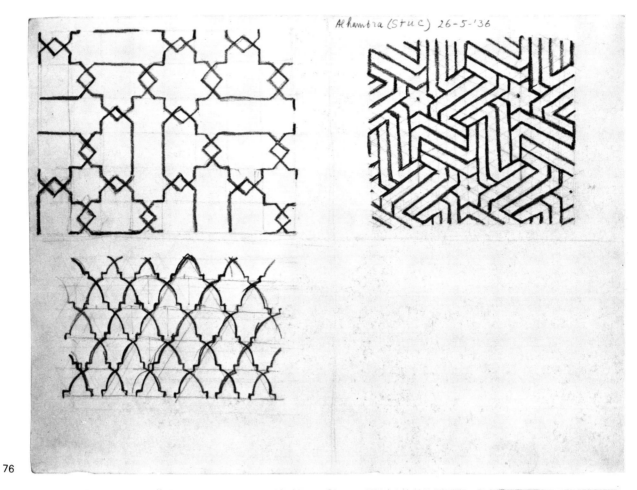

76

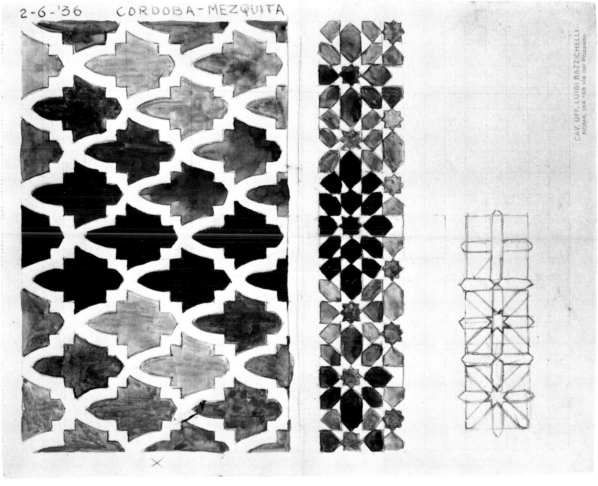

77

76. Copy of mosaics in the Alhambra. 1936
Pencil, 239×318 (9⅜×12½'')
Dated and inscribed: Alhambra (Stuc) 26-5-'36

77. Copy of mosaics in La Mezquita, Córdoba. 1936
Pencil and watercolor, 220×282 (8⅝×11⅛'')
Dated and inscribed: 2-6-'36 CORDOBA-MEZQUITA

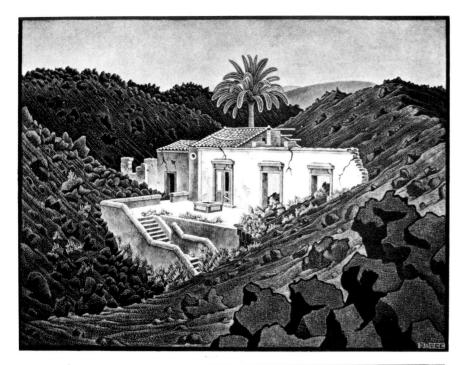

78

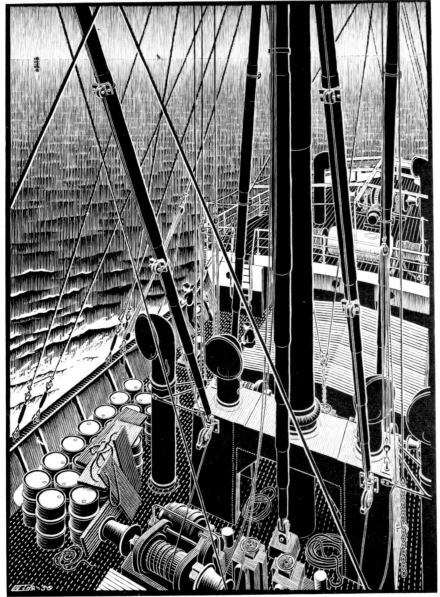

79

78. House in the Lava near Nunziata, Sicily. 1936
Lithograph, 270×355 (10⅝×14'')
Signed and dated: 8-'36 MCE

79. Freighter. 1936
Woodcut, 504×367 (19⅞×14½'')
Signed and dated: MCE 9-'36

72

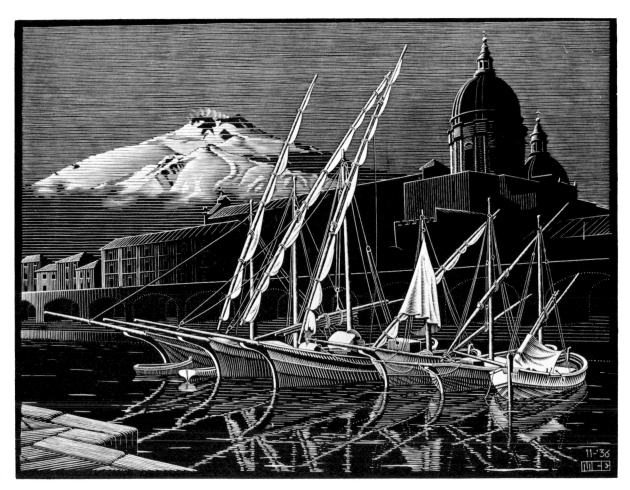

80

80. Catania and Mt. Etna. 1936
 Wood engraving, 239×320 (9⅜×12⅝″)
 Signed and dated: 11-'36 MCE

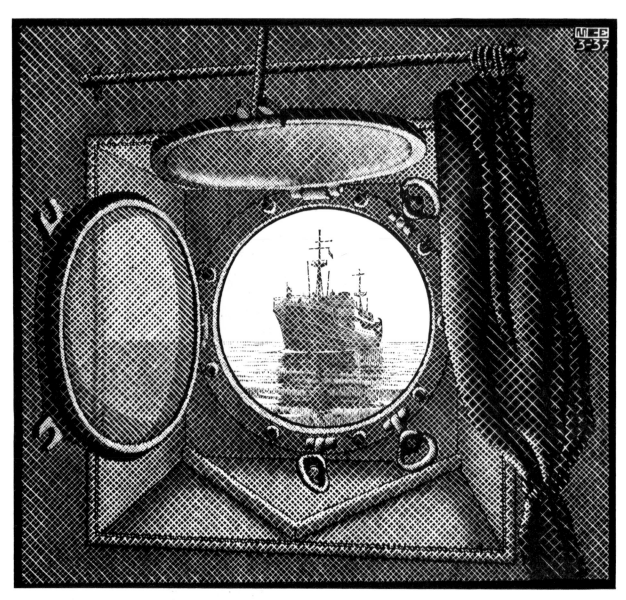

81

81. Porthole. 1937
Woodcut, 258×277 (10⅛×10⅞'')
Signed and dated: MCE 3-'37

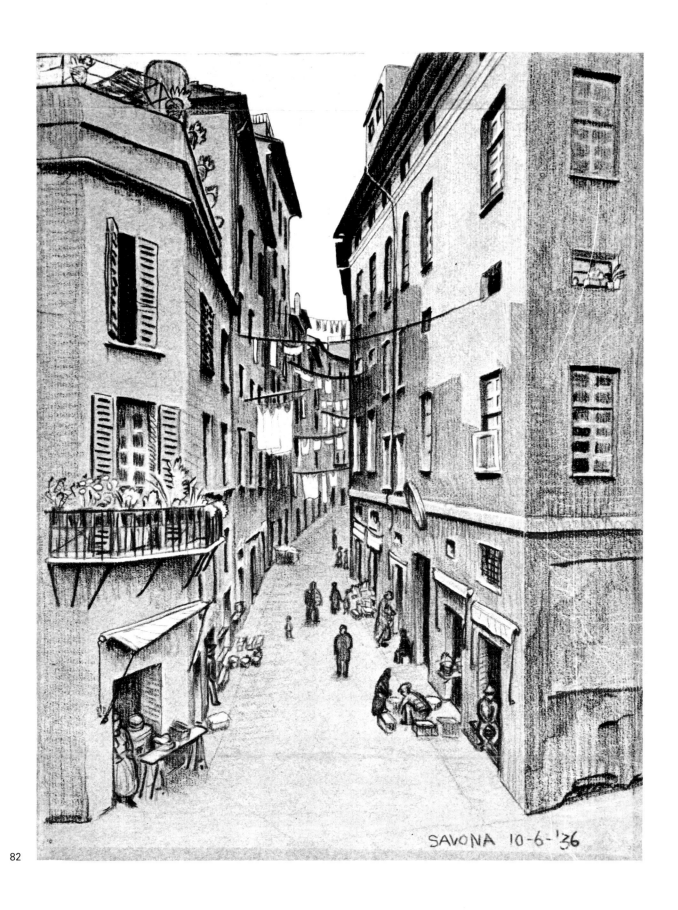

82

82. Savona. 1936
 Black and white crayons, 315×239 (12⅜×9⅜'')
 Dated and inscribed: SAVONA 10-6-'36
 Collection G. W. Locher, Leiden (used for the woodcut
 Still Life and Street, no. 83)

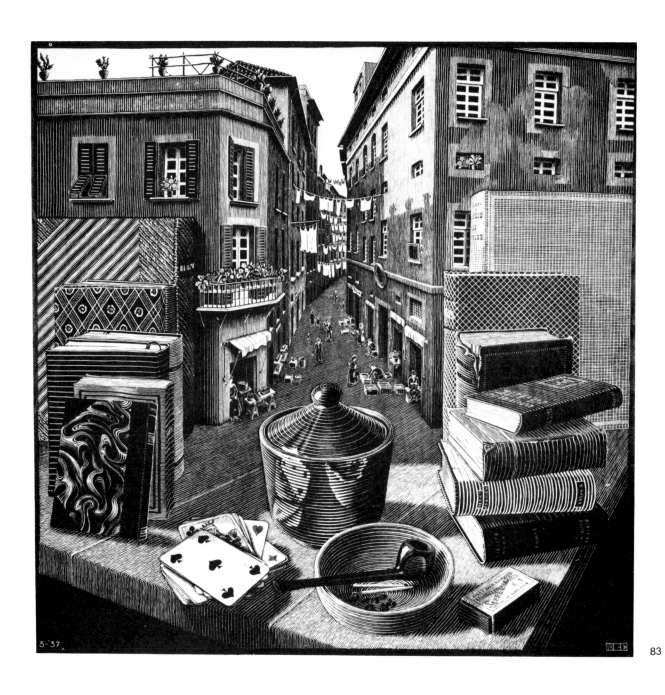

83

83. Still Life and Street. 1937
 Woodcut, 490×490 (19¼×19¼'')
 Signed and dated: 3-'37 MCE

84. Study of Regular Division of the Plane with Human
 Figures. 1936
 Pencil and watercolor in blue and ocher, 357×270
 (14×10⅝'')
 Dated and inscribed: driehoek systeem I A3 type 1*
 Château-d'Oex X-'36 (used for the woodcut
 Metamorphosis I, 1937, no. 85)

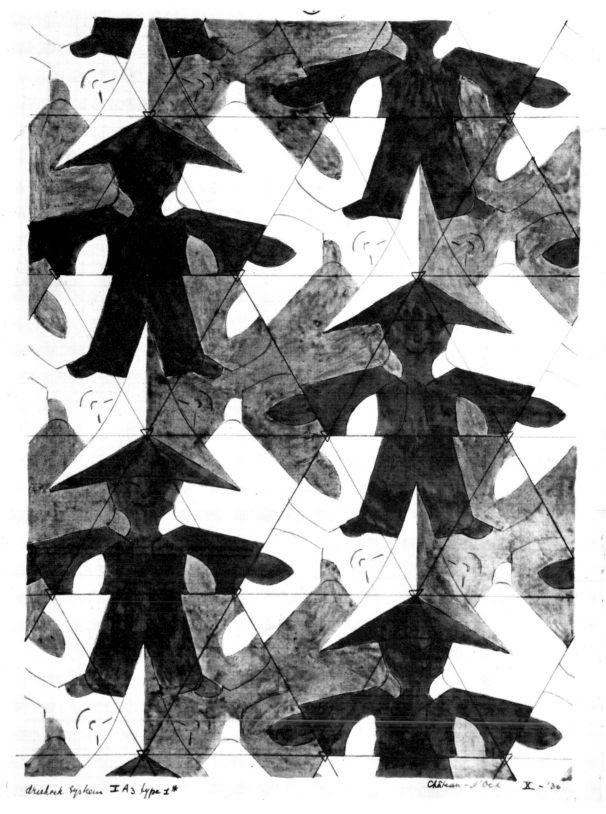

84 driehoek systeem I A₃ type 1* Château-d'Oex X-'36

85

85. Metamorphosis I. 1937
 Woodcut, 195×908 (7⅘×35¾'')
 Signed and dated: V-'37 MCE

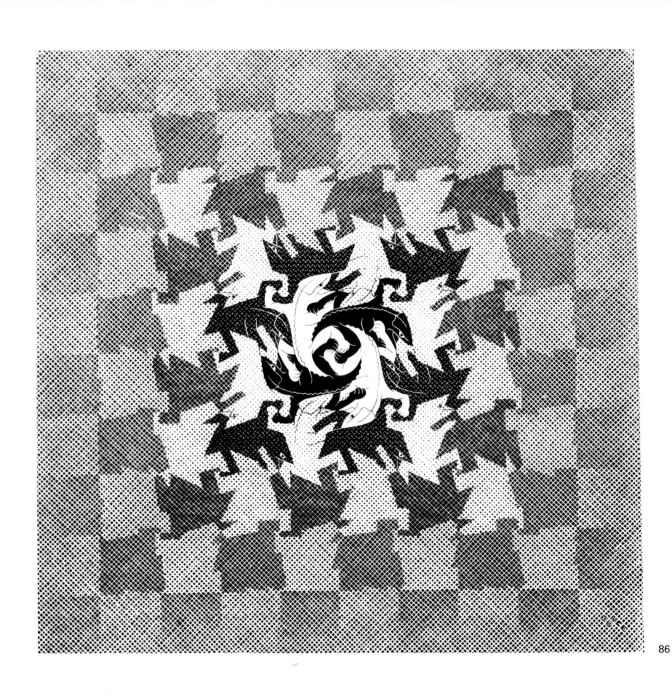

86

86. Development I. 1937
 Woodcut, 440×445 (17¾×17½'')
 Signed and dated: MCE XI 37

87. Study of Regular Division of the Plane with Birds. 1938
 India ink, pencil, and watercolor in blue, 357×268
 (14×10½'')
 Dated and inscribed: 2-motieven: overgangs-systeem IA-
 IA Ukkel, 11-'38 (used for the woodcut Day and Night,
 1938, no. 88)

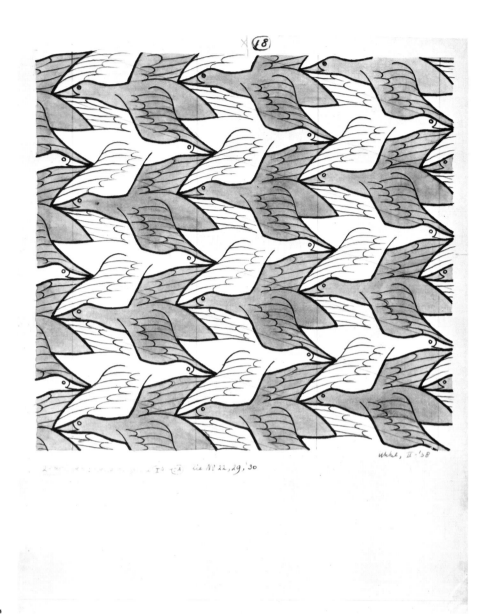

87

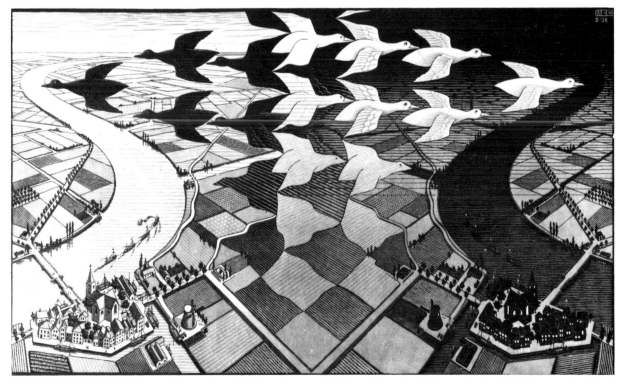

88

88. Day and Night. 1938
 Woodcut in two colors, 393×678 (15½×26¾'')
 Signed and dated: MCE II-'38

89

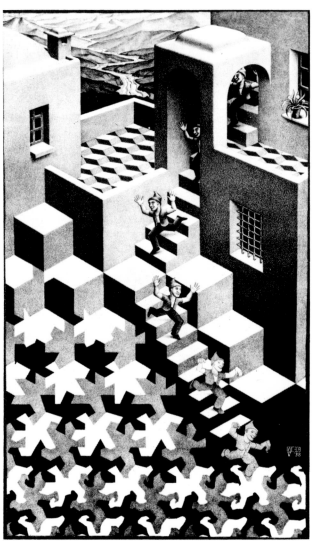

90

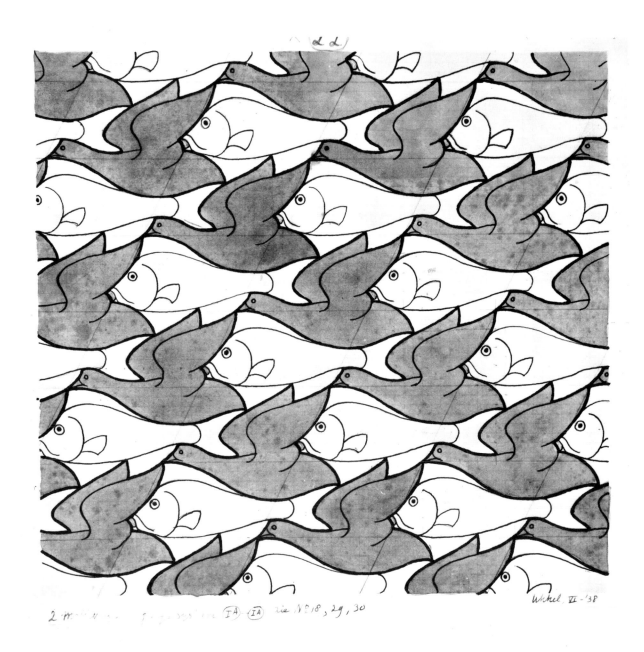

91

89. Study of Regular Division of the Plane with Human
 Figures. 1938
 India ink, pencil, and watercolor in blue, yellow, and red,
 258×270 (10⅛×10⅝")
 Dated and inscribed: driehoekssysteem I A3 type 1 Ukkel,
 V-'38 (used for the lithograph Cycle, 1938, no. 90)

90. Cycle. 1938
 Lithograph, 475×277 (18¾×10⅞")
 Signed and dated: MCE V'38

91. Study of Regular Division of the Plane with Fish and
 Birds. 1938
 India ink, watercolor in red, and pencil, 358×269
 (14⅛×10⅝")
 Dated and inscribed: 2 motieven: overgangs-systeem
 IA-IA Ukkel, VI-'38 (used for the woodcut Sky and Water I,
 1938, no. 92)

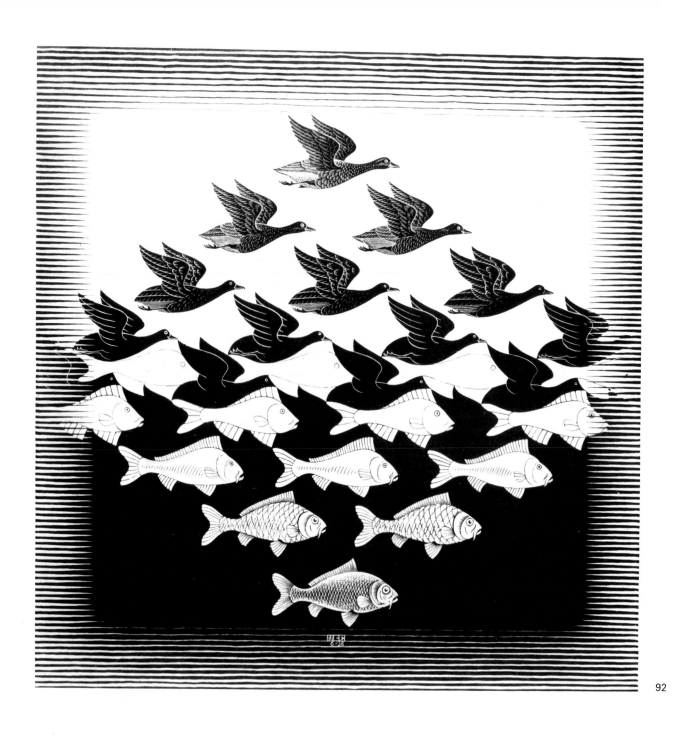

92. Sky and Water I. 1938
 Woodcut, 440×440 (17⅜×17⅜")
 Signed and dated: MCE 6-'38

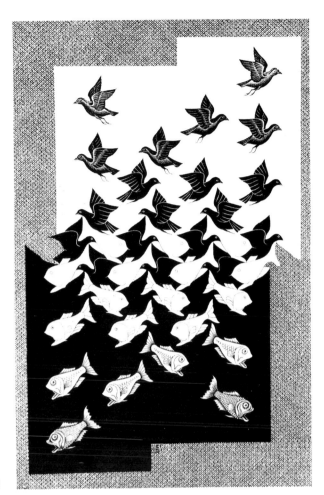

93

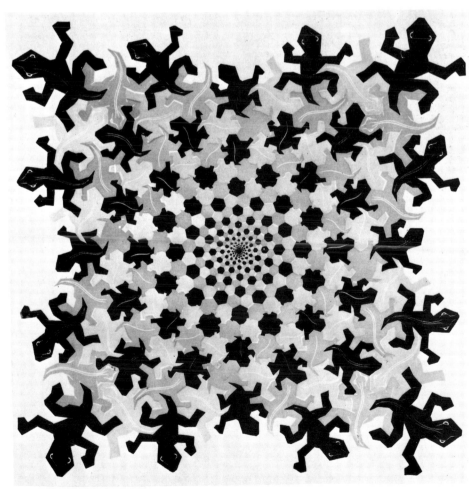

94

93. Sky and Water II. 1938
 Woodcut, 410×620 (16⅛×24⅜'')
 Signed and dated: MCE XII-'38

94. Development II. 1939
 Woodcut in three colors, 455×455 (17⅞×17⅞'')

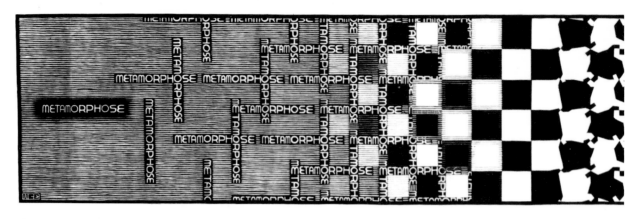

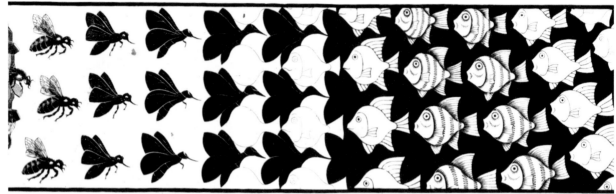

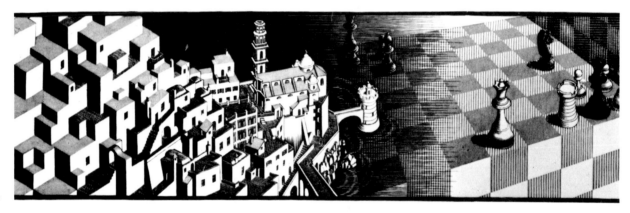

95

95. Metamorphosis II. 1939-40
 Woodcut in three colors, 195×4000 (7⅝×157½")
 Signed and dated: MCE XI'39-III'40

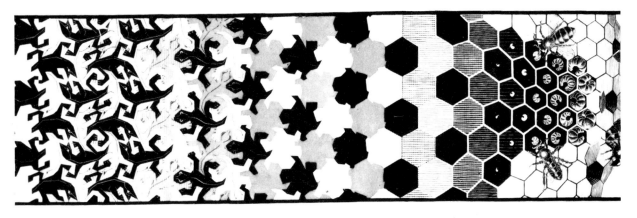

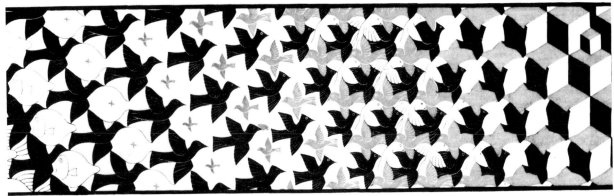

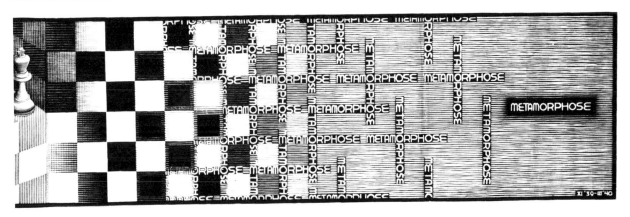

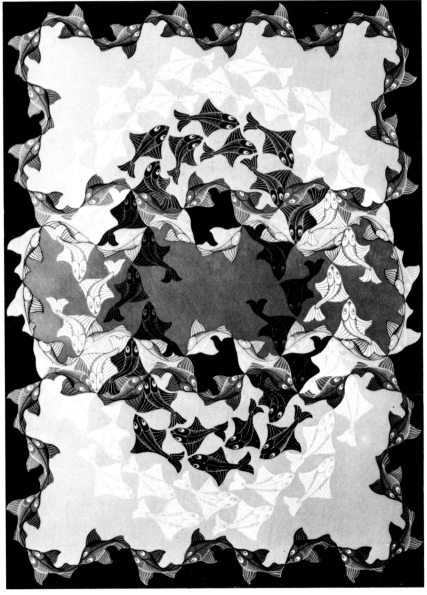

96

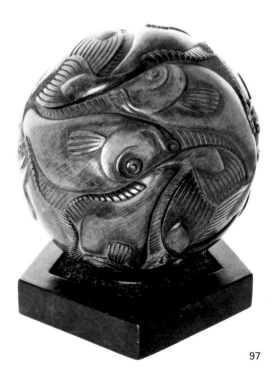

97

98

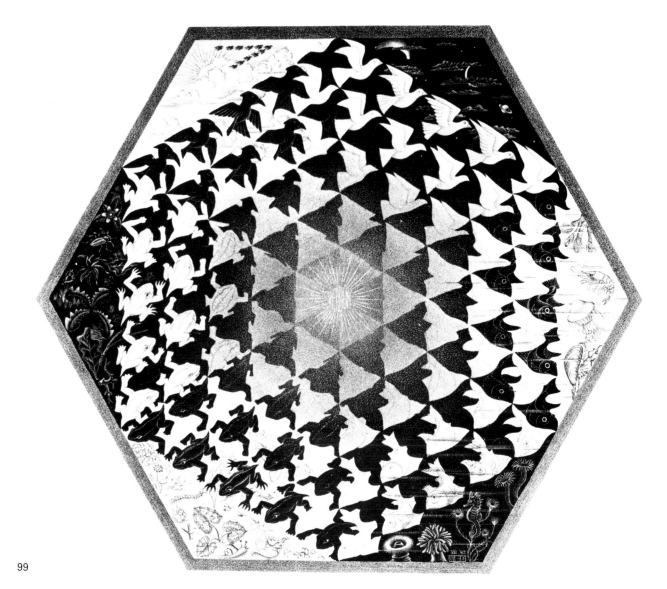

99

100

96. Fish. 1941
Woodcut in three colors, 506×382 (20×15'')

97. Sphere with Fish. 1940
Stained beech, diameter 140 (5½'')

98. Sphere with Angels and Devils. 1942
Stained maple, diameter 235 (9¼'')

99. Verbum. 1942
Lithograph, 330×385 (13×15⅛'')
Signed and dated: VII'42 MCE

100. Sphere with Human Figures. 1943
Stained wood, diameter 130 (5⅛'')

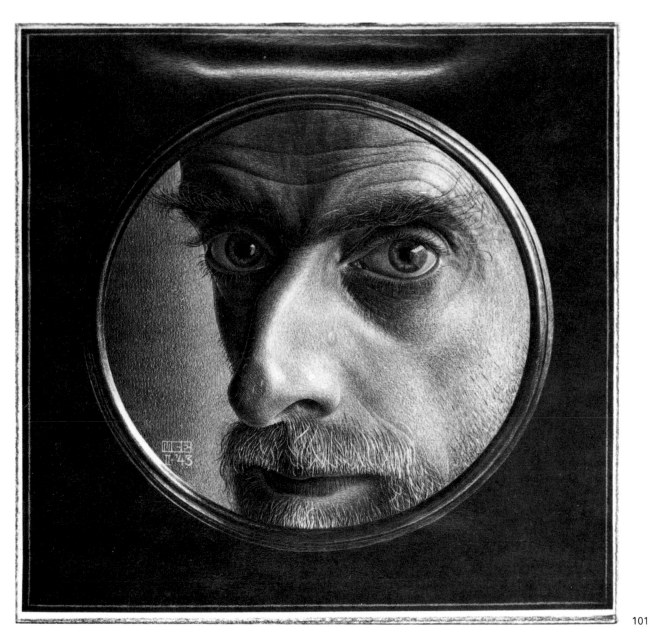

101

101. Self-Portrait. 1943
Lithographic ink ("scratch" drawing), 248 x 255 (9¾ x 10")
Signed and dated: MCE II-'43

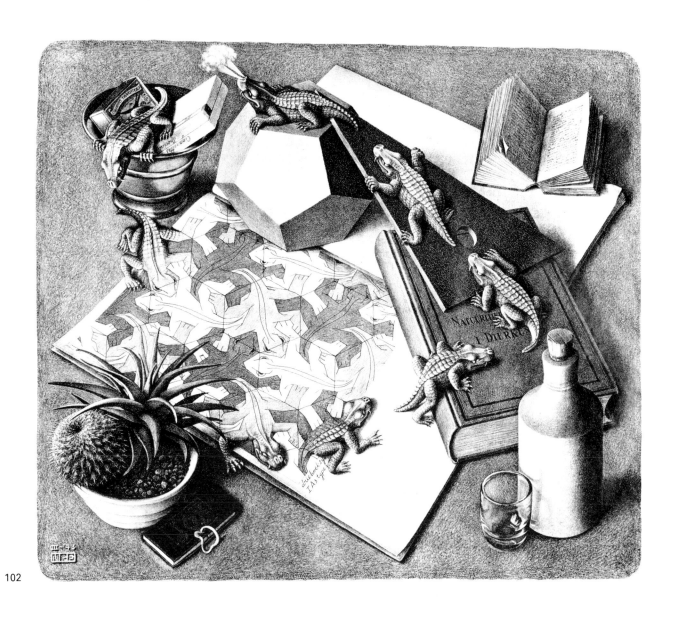

102

102. Reptiles. 1943
 Lithograph, 334×386 (13⅛×15¼'')
 Signed and dated: III-'43 MCE

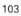

103

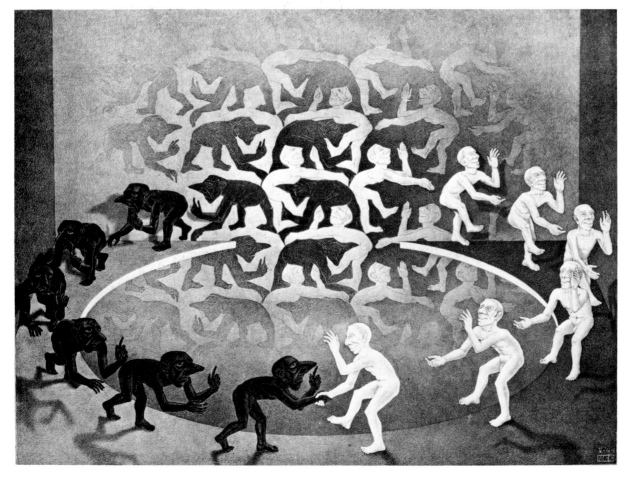

104

103. Study of Regular Division of the Plane with Human
Figures. 1944
Pencil and india ink, 227×303 (8$\frac{7}{8}$×11$\frac{7}{8}$″)
Dated and inscribed: 2-motieven systeem IV B-V C variant
2 Baarn II-'44 (used for the lithograph Encounter, 1944,
no. 104)

104. Encounter. 1944
Lithograph, 342×469 (13$\frac{1}{2}$×18$\frac{1}{2}$″)
Signed and dated: V-'44 MCE

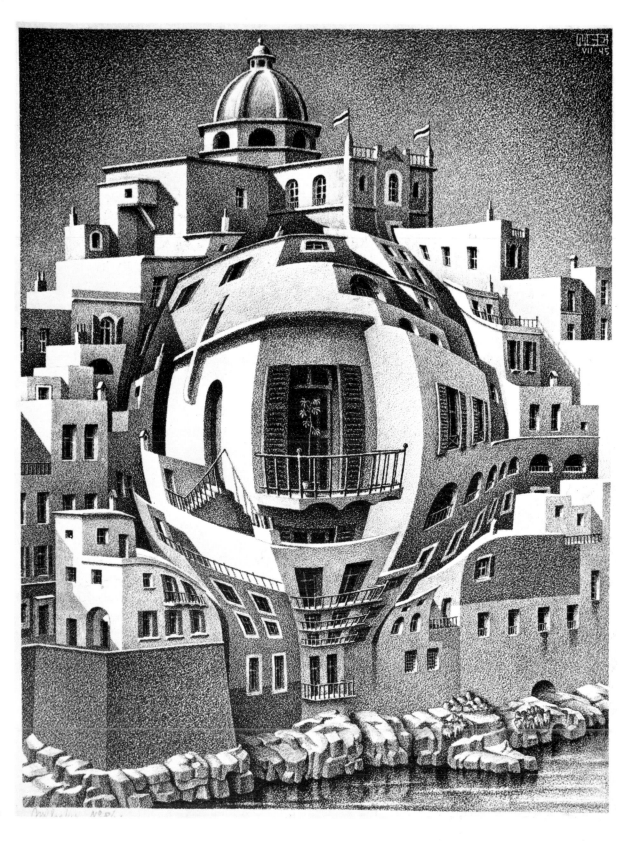

105

105. Balcony. 1945
Lithograph, 297×235 (11¾×9¼″)
Signed and dated: MCE VII-45

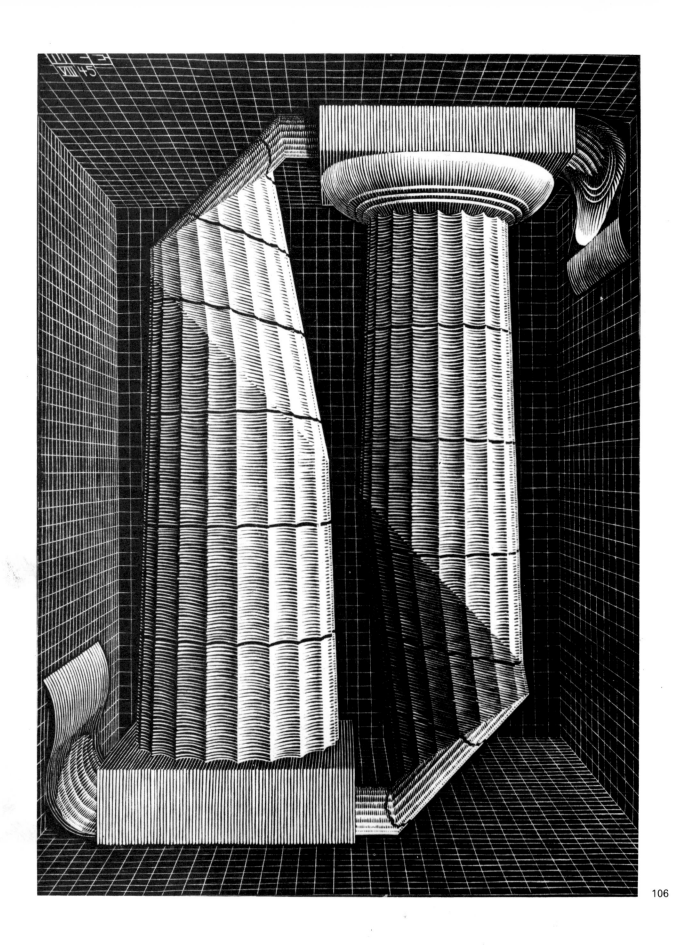

106

106. Doric Columns. 1945
Wood engraving in three colors, 322×241 (12⅝×9½″)
Signed and dated: MCE VIII 45

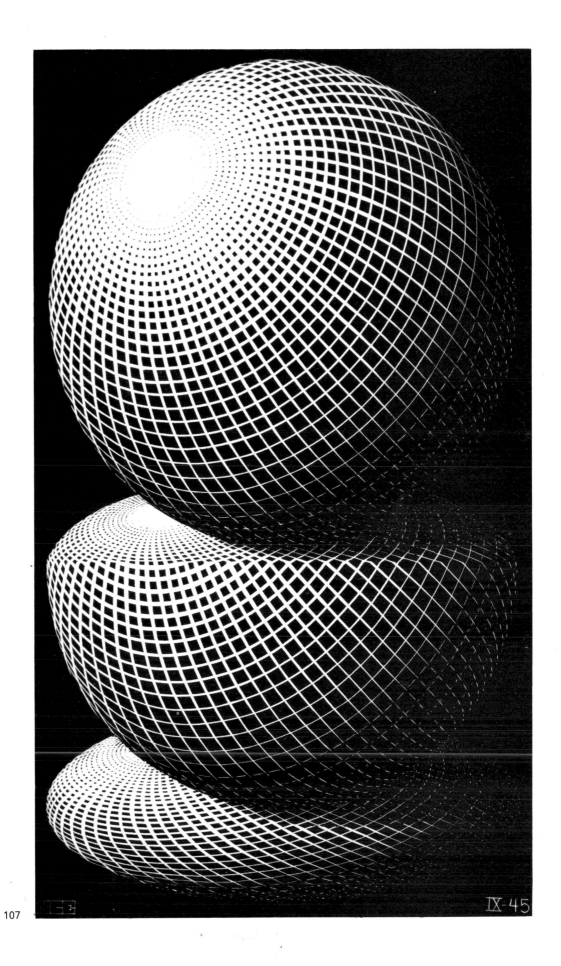

107. Three Spheres I. 1945
 Wood engraving, 279×168 (11×6⅝'')
 Signed and dated: MCE IX-45

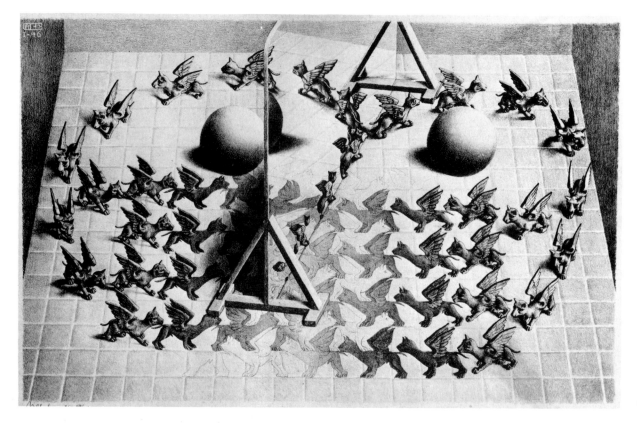

108

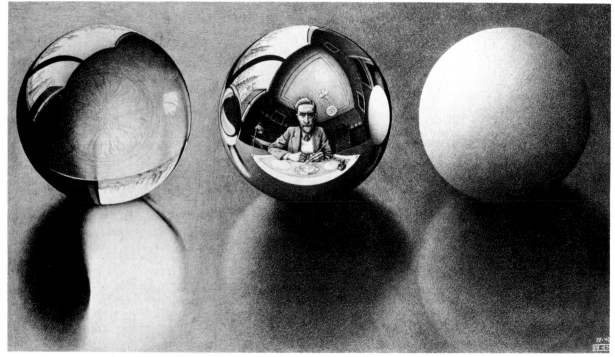

109

108. Magic Mirror. 1946
 Lithograph, 230×445 (9×17½″)
 Signed and dated: MCE 1- 46

109. Three Spheres II. 1946
 Lithograph, 260×464 (10¼×18¼)
 Signed and dated: IV-46 MCE

110

110. Dusk. 1946
Mezzotint, 117 x 100 (4⅝ x 3⅞'')
Signed and dated: MCE V 46

111

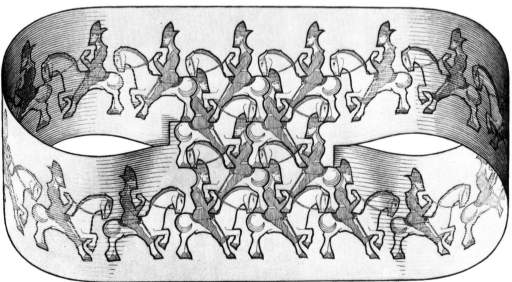

112

111. Study of Regular Division of the Plane with Horsemen. 1946
India ink and watercolor, 304×229 (12×9'')
Signed and inscribed: systeem IV B Baarn VI-'46

112. Horseman. 1946
Woodcut in three colors, 240×448 (9½×17⅝'')
Signed and dated: VII-'46 MCE

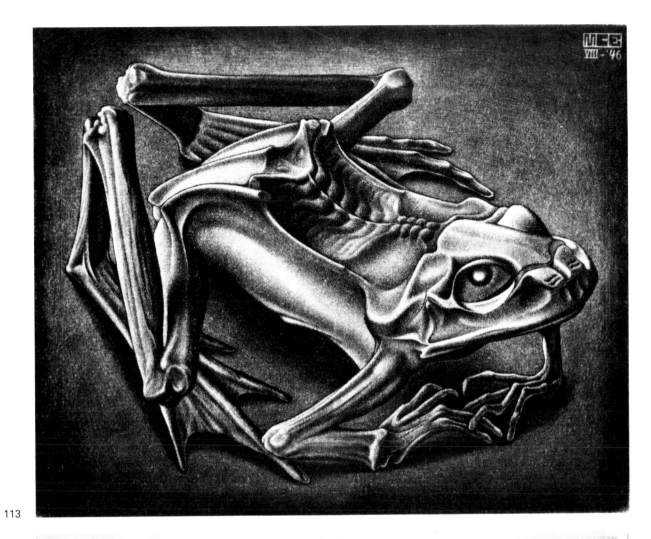

113

114

113. Mummified Frog. 1946
 Mezzotint, 137×173 (5⅜×6⅞'')
 Signed and dated: MCE VIII-'46

114. Eye. 1946
 Mezzotint, 151×203 (6×8'')
 Signed and dated: X-46 MCE

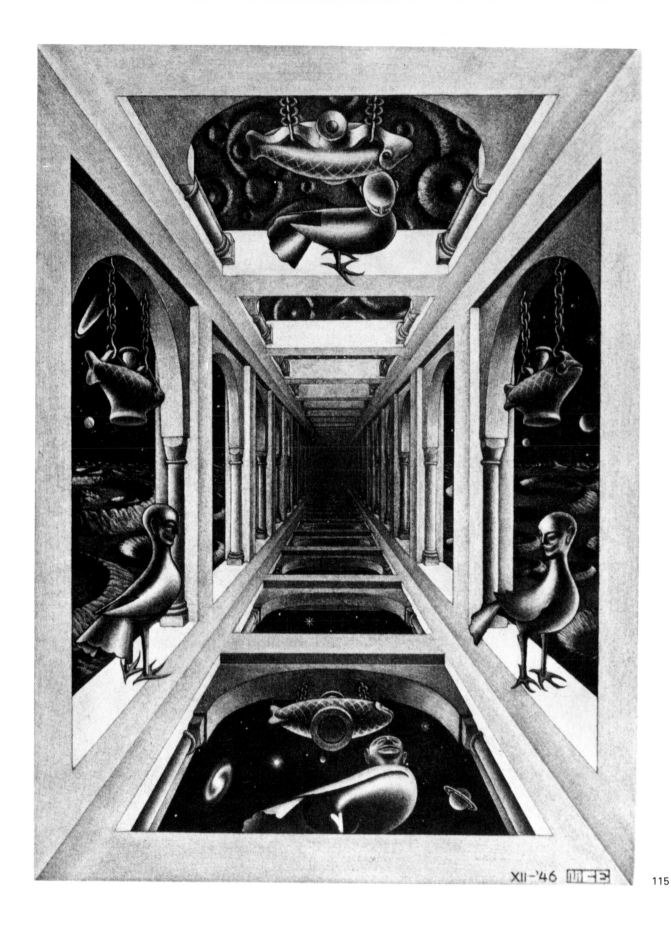

115

115. Other World. 1946
Mezzotint, 218×161 (8⅝×6⅜'')
Signed and dated: XII-'46 MCE (preliminary drawing for
the wood engraving Other World, 1947, no. 116)

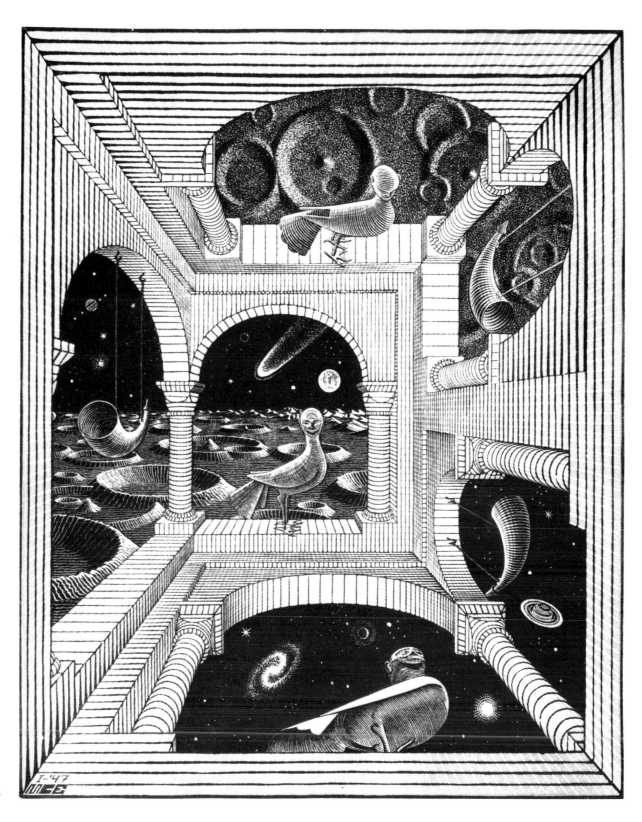

116

116. Other World. 1947
 Wood engraving in three colors, 317×260 (12½×10¼″)
 Signed and dated: 1-'47 MCE

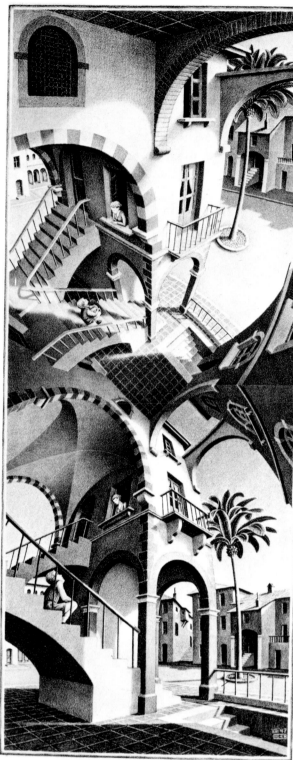

117. Study for the lithograph "Up and Down." 1947
Pencil, 535×230 (21⅛×9")

118. Up and Down. 1947
Lithograph, 505×205 (19⅞×8⅛")
Signed and dated: VII-'47 MCE

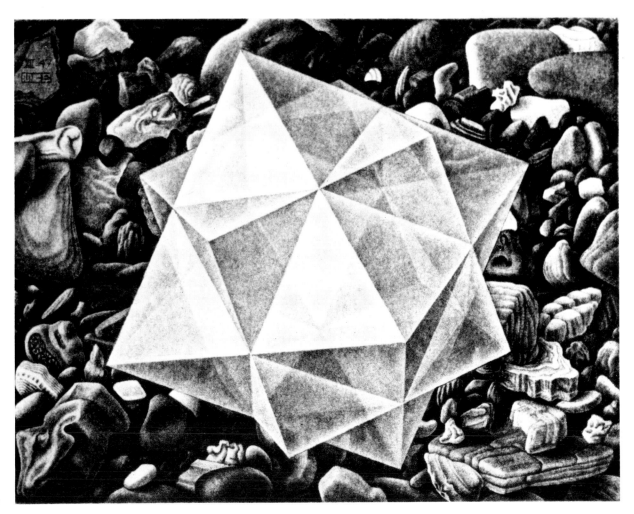

119

119. Crystal. 1947
Mezzotint, 138×171 (5⅜×6¾'')
Signed and dated: XII-'47 MCE

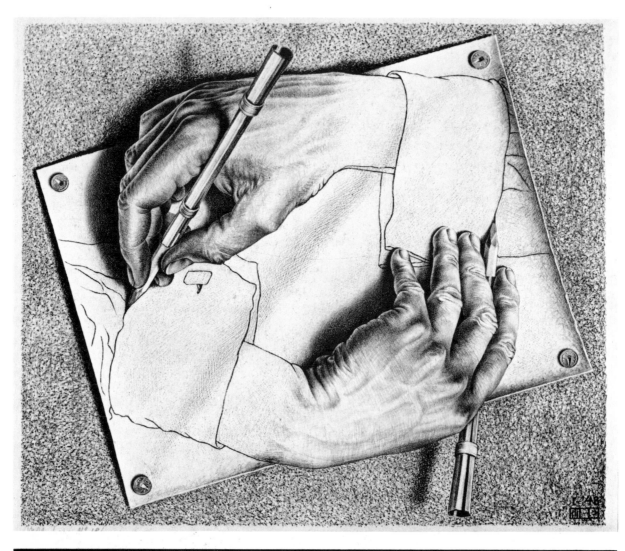

120

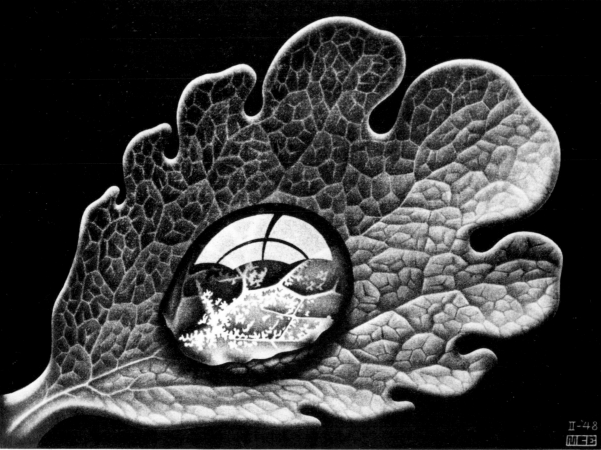

121

120. Drawing Hands. 1948
Lithograph, 282×333 (11⅛×13⅛'')
Signed and dated: I-'48 MCE

121. Dewdrop. 1948
Mezzotint, 178×245 (7×9⅝'')
Signed and dated: Il-'48 MCE

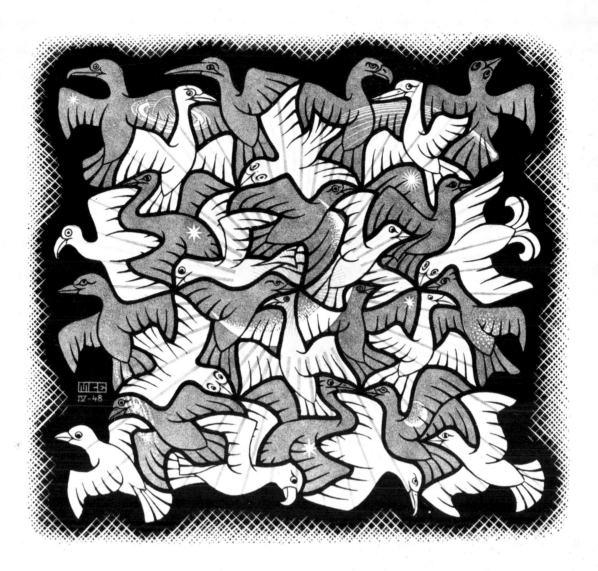

122

122. Sun and Moon. 1948
 Woodcut in four colors, 252×277 (10×10$\frac{7}{8}$'')
 Signed and dated: MCE IV-48

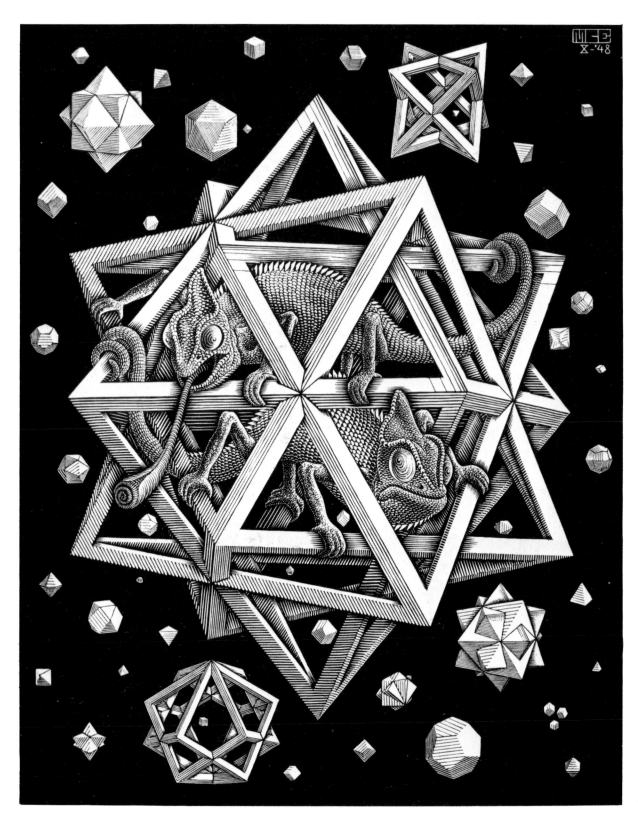

123

123. Stars. 1948
 Wood engraving, 317 x 258 (12½ x 10⅛'')
 Signed and dated: MCE X-'48

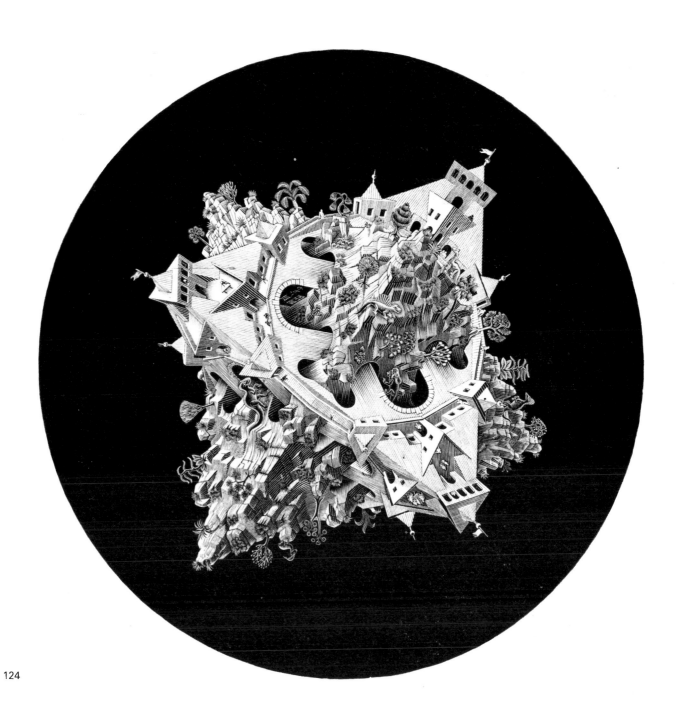

124

124.	Double Planetoid. 1949
	Wood engraving in two colors, diameter 375 (14¾'')
	Signed and dated: XII-'49 MCE

125. Order and Chaos. 1950
 Lithograph, 280×280 (11×11″)
 Signed and dated: II-'50 MCE

126

126. Rippled Surface. 1950
Linoleum cut in two colors, 260×320 (10¼×12⅝")
Signed and dated: MCE III-'50

127. Butterflies. 1950
Wood engraving, 280×260 (11×10¼'')
Signed and dated: VI-50 MCE

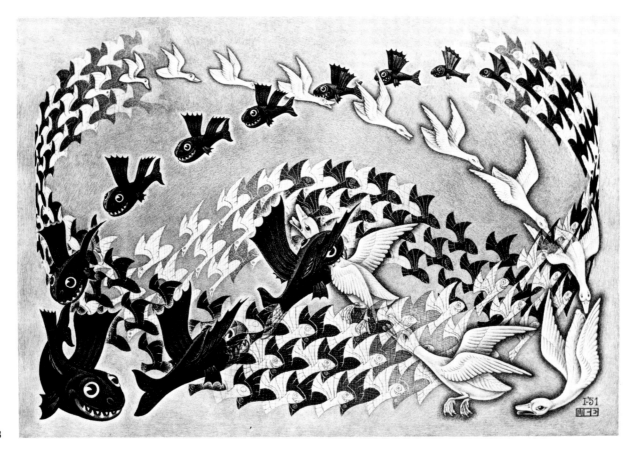

128

129

128. Predestination. 1951
 Lithograph, 292×420 (11½×16½'')
 Signed and dated: I-'51 MCE

129. Mosaic I. 1951
 Mezzotint, 150×202 (5⅞×8'')
 Signed and dated: MCE III-51

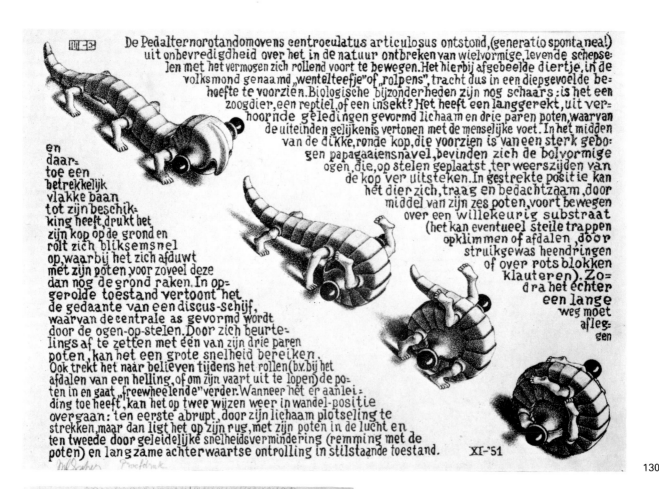

130

131

130. Curl-up. 1951
Lithograph, 178×244 (7×9⅝")
Signed and dated: MCE XI-'51

131. Study for the lithograph "House of Stairs." 1951
Red, green, and india ink, 546×377 (21½×14⅞")

110

132

132. Study for the lithograph "House of Stairs." 1951
India ink and pencil, 415×308 (16⅜×12⅛")

133

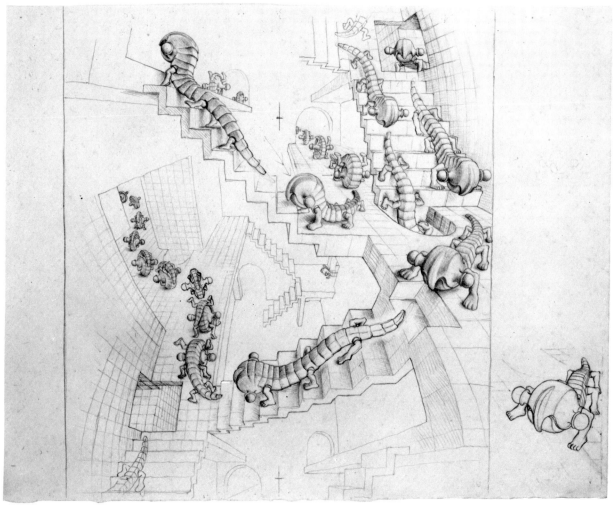

134

133. Study for the lithograph "House of Stairs." 1951
Pencil, 249 × 191 (9¾ × 7½")

134. Study for the lithograph "House of Stairs." 1951
Pencil, 274 × 378 (10¾ × 14⅞")

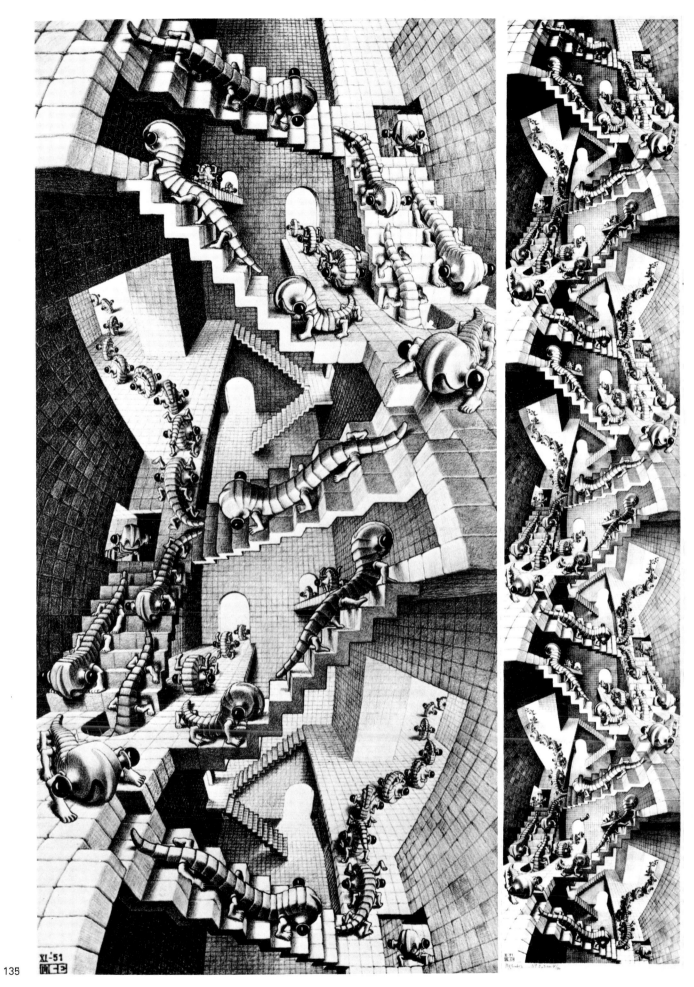

135

136

136. House of Stairs II. 1951
Lithograph, 1410×240 (55½×9½'')
Signed and dated: XI-'51 MCE (this picture is a series of
three copies of the lithograph House of Stairs I, 1951, no.
135)

135. House of Stairs I. 1951
Lithograph, 470×240 (18½×9½'')
Signed and dated: XI-'51 MCE

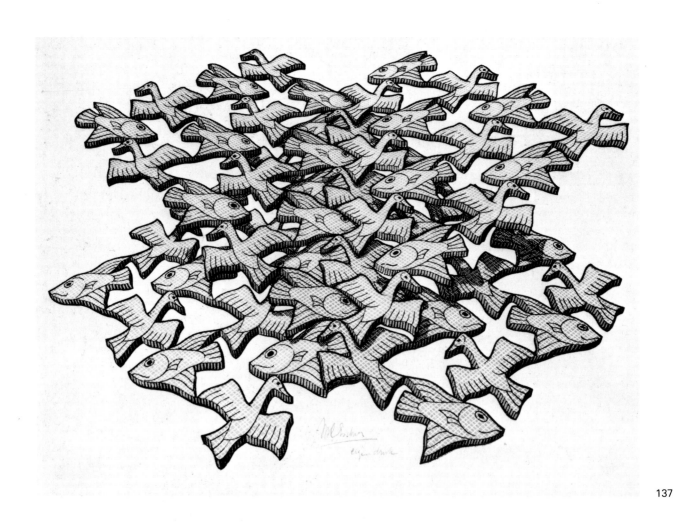

137

137. Two Intersecting Planes. 1952
Woodcut in three colors, 255×320 (10×12⅝")
Signed and dated: I-52 MCE

114

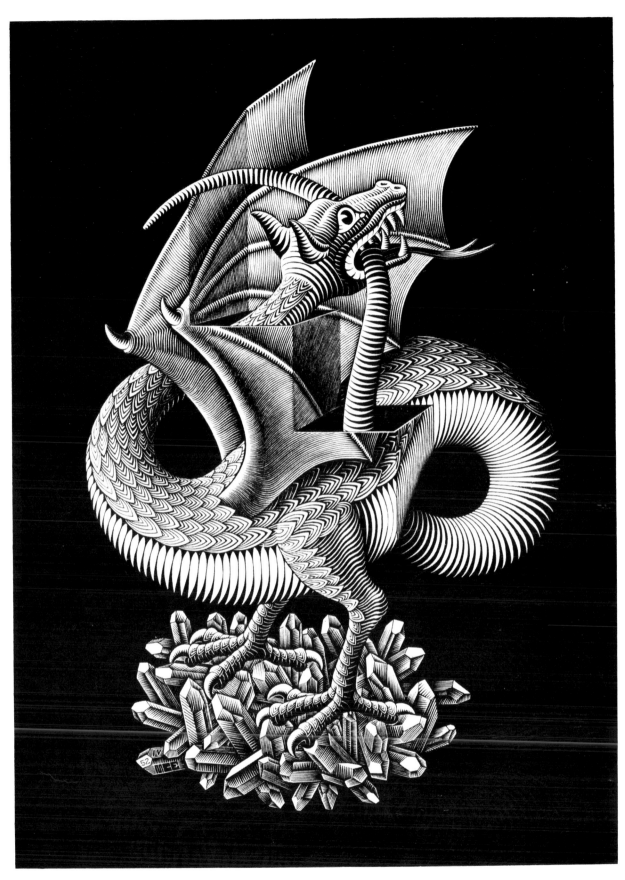

138

138. Dragon. 1952
Wood engraving, 322×242 (12⅝×9½'')
Signed and dated: IV 52 MCE

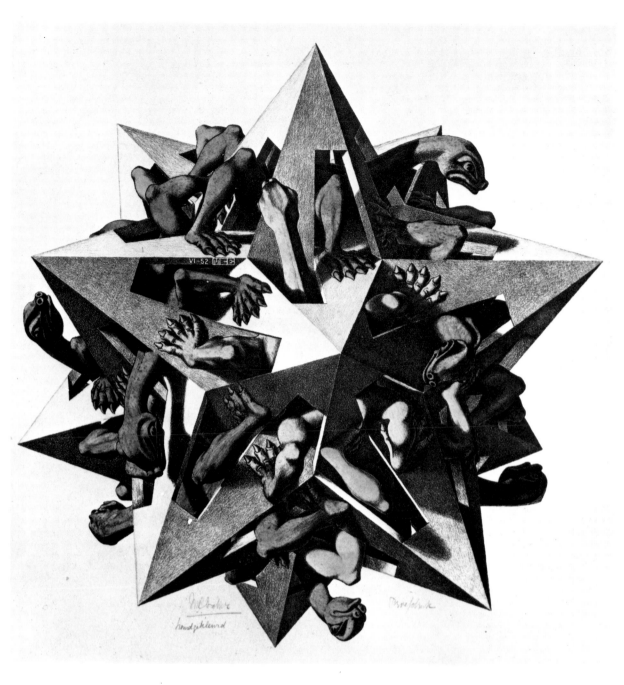

139. Gravity. 1952
 Lithograph and watercolor in red, orange, purple, green,
 yellow, and blue, 300×300 (11¾×11¾")
 Signed and dated: VI-52 MCE

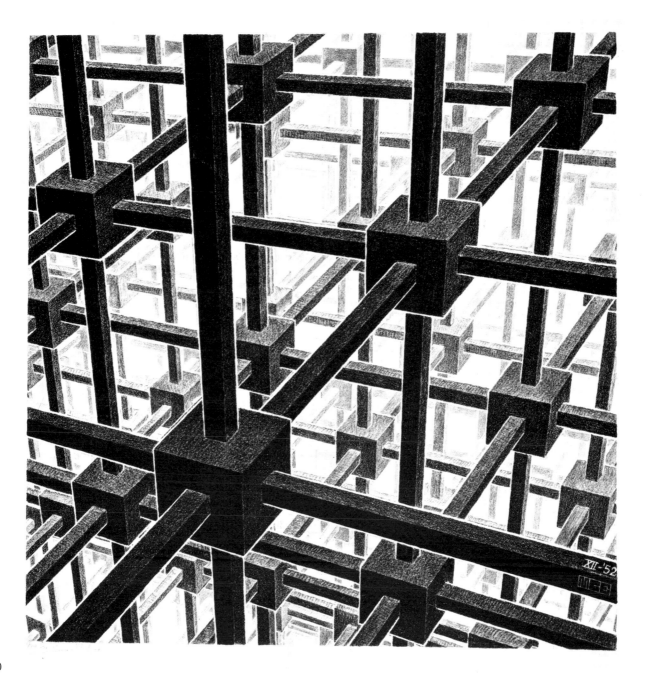

140

140. Cubic Space Division. 1952
Lithograph, 266×266 (10½×10½")
Signed and dated: XII-'52 MCE´

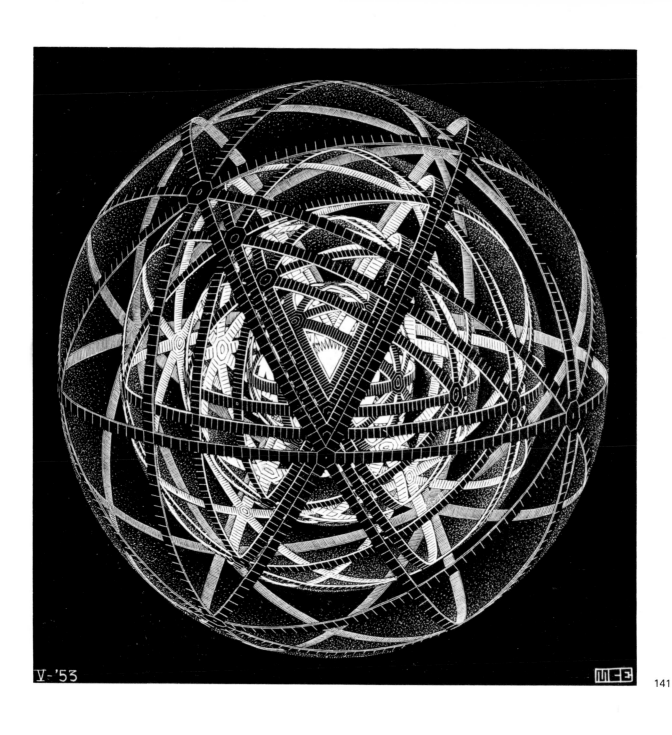

141. Concentric Rinds. 1953
 Wood engraving, 240×240 (9½×9½")
 Signed and dated: V-'53 MCE

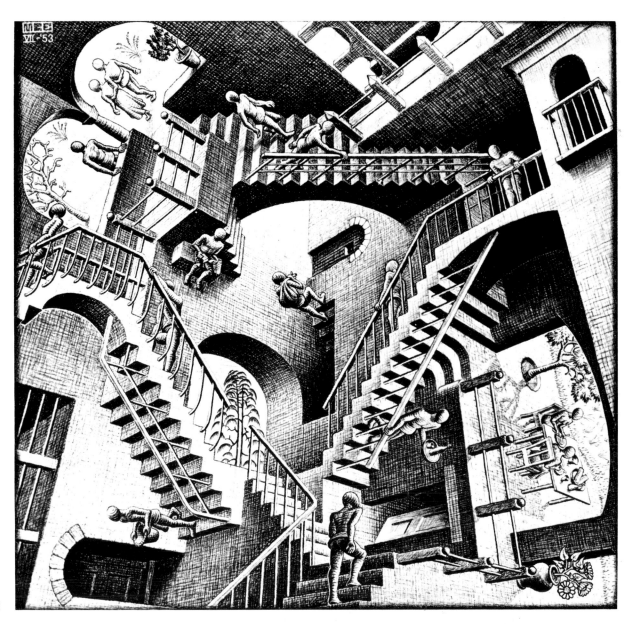

142

142. Relativity. 1953
 Lithograph, 272×293 (10¾×11½'')
 Signed and dated: MCE VII-'53

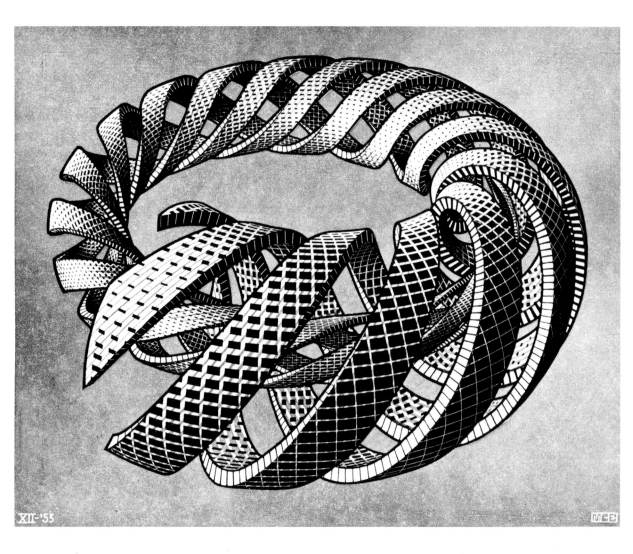

143. Spirals. 1953
 Wood engraving in two colors, 270 x 332 (10⅝ x 13⅛")
 Signed and dated: XII-'53 MCE

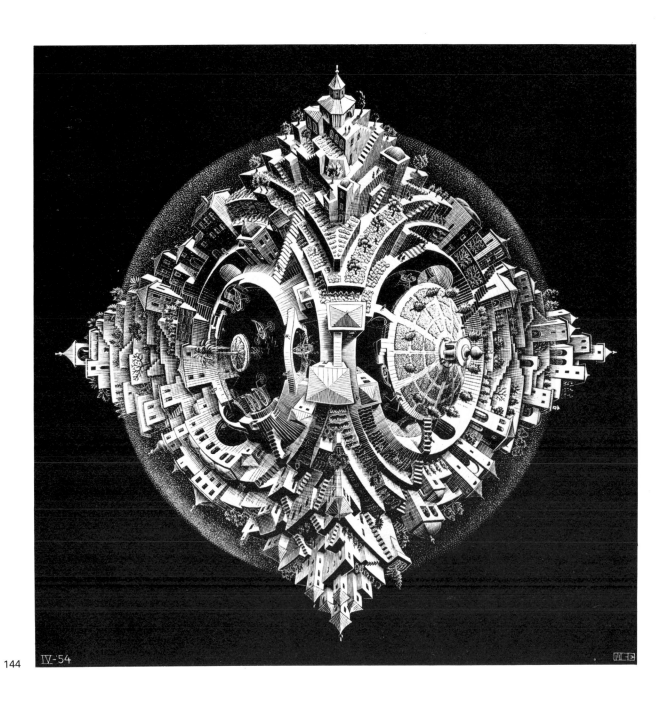

144 IV-'54

144. Tetrahedral Planetoid. 1954
 Woodcut in two colors, 430×430 ($16\frac{7}{8}$ × $16\frac{7}{8}$'')
 Signed and dated: VI-'54 MCE

145/146

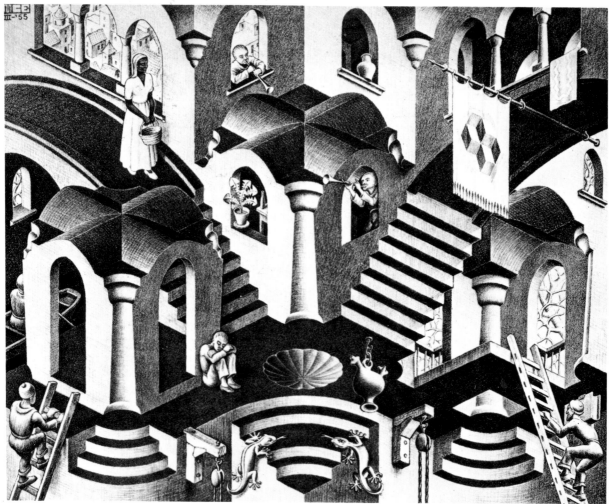

147

145. Study for the lithograph "Convex and Concave." 1955
 Pencil, 327×210 (12$\frac{7}{8}$×8$\frac{1}{4}$")

146. Study for the lithograph "Convex and Concave." 1955
 Pencil, 155×212 (6$\frac{1}{8}$×8$\frac{3}{8}$")

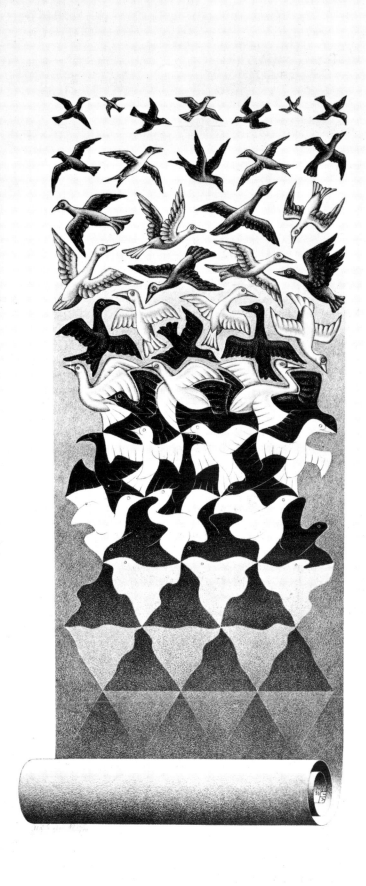

148

147. Convex and Concave. 1955
 Lithograph, 275×335 (10⅞×13⅛'')
 Signed and dated: MCE III-'55

148. Liberation. 1955
 Lithograph, 440×200 (17⅜×7⅞'')
 Signed and dated: IV 55 MCE

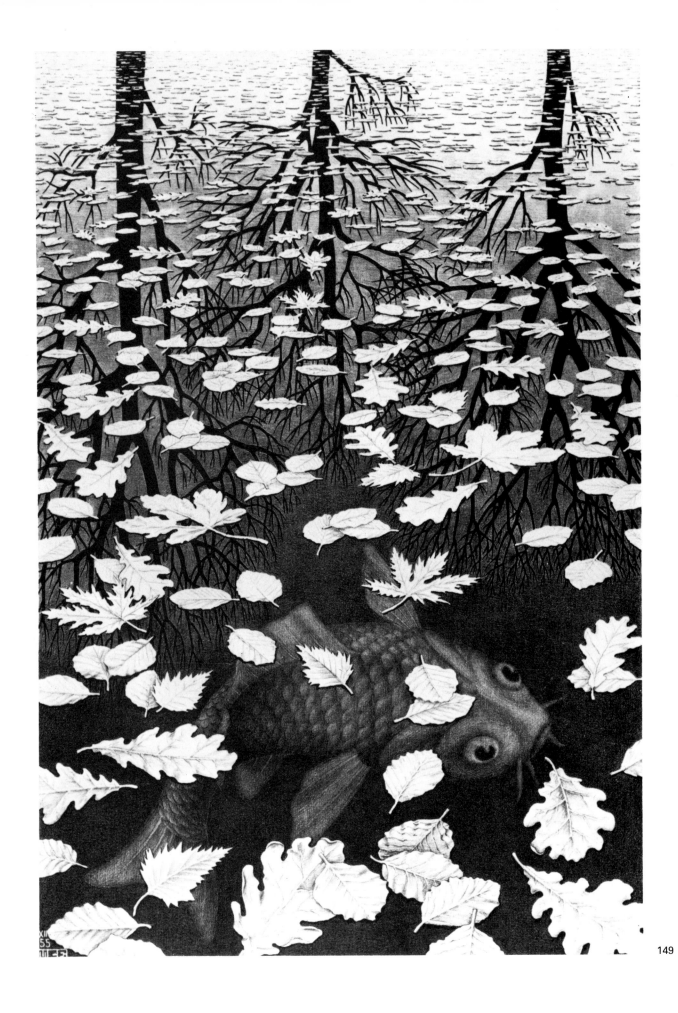

149. Three Worlds. 1955
Lithograph, 361×247 (14⅛×9¾'')
Signed and dated: XII 55 MCE

149

150

150. Study of Regular Division of the Plane with Birds. 1955
India ink and watercolor in gray brown, 303×225
(11⅞ x 8⅞'')
Dated and inscribed: systeem IV D Baarn XII-'55
(used for the wood engraving Swans, 1956, no. 151)

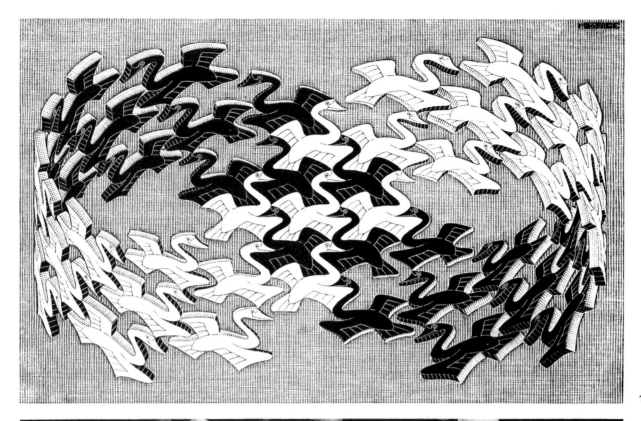

151

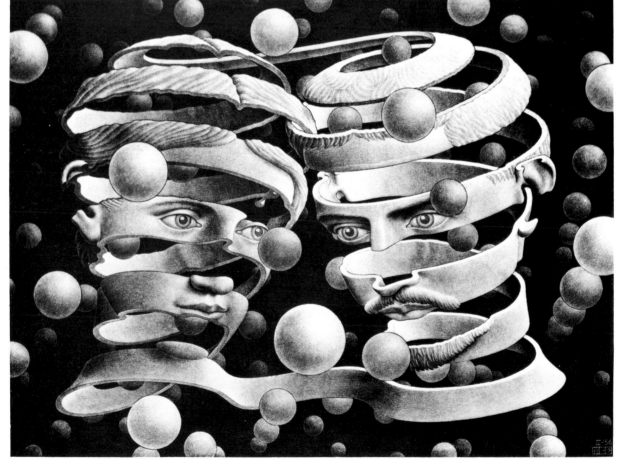

152

151. Swans. 1956
 Wood engraving, 200×320 (7⅞×12⅝")
 Signed and dated: II-'56 MCE

152. Bond of Union. 1956
 Lithograph, 255×339 (10×13⅜")
 Signed and dated: IV-'56 MCE

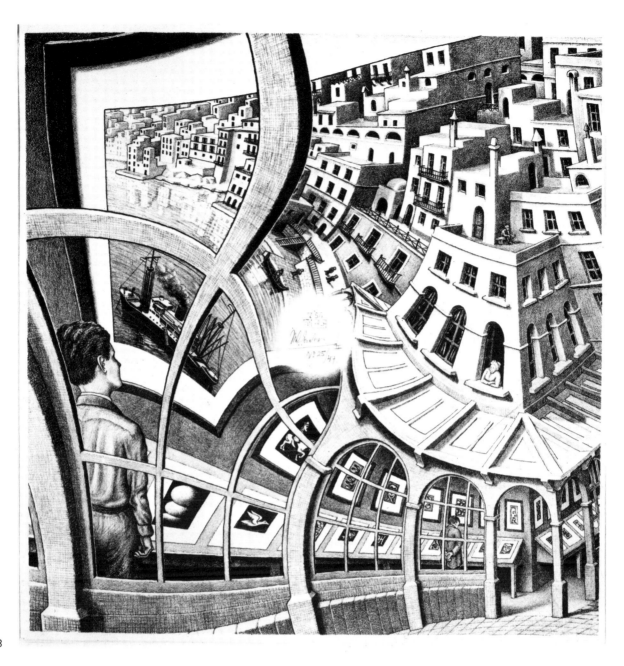

153

153. Print Gallery. 1956
Lithograph, 320×315 (12⅝×12⅜")
Signed and dated: V-'56 MCE

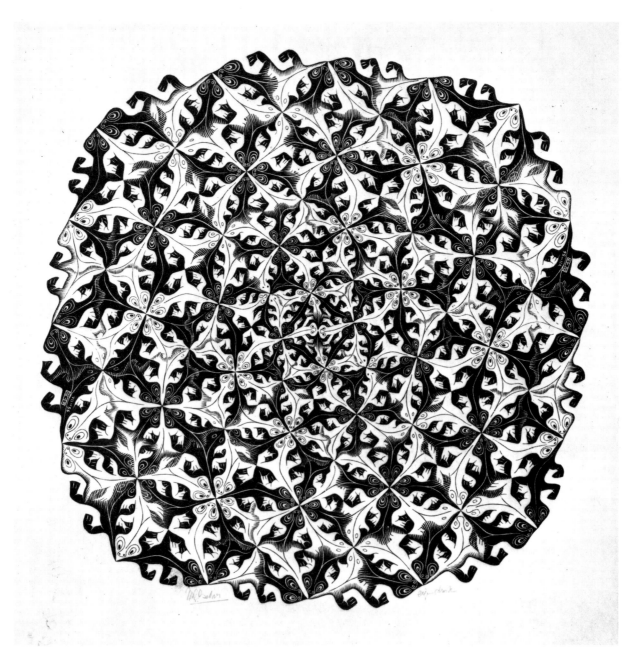

154. Division. 1956
Woodcut, 380×380 (15×15'')
Signed and dated: VII-'56 MCE

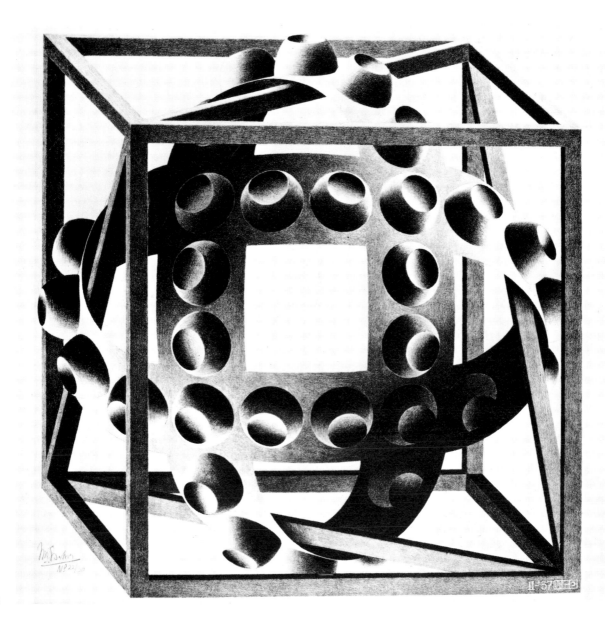

155

155. Cube with Magic Ribbons. 1957
Lithograph, 310×305 (12¼×12″)
Signed and dated: II-'57 MCE

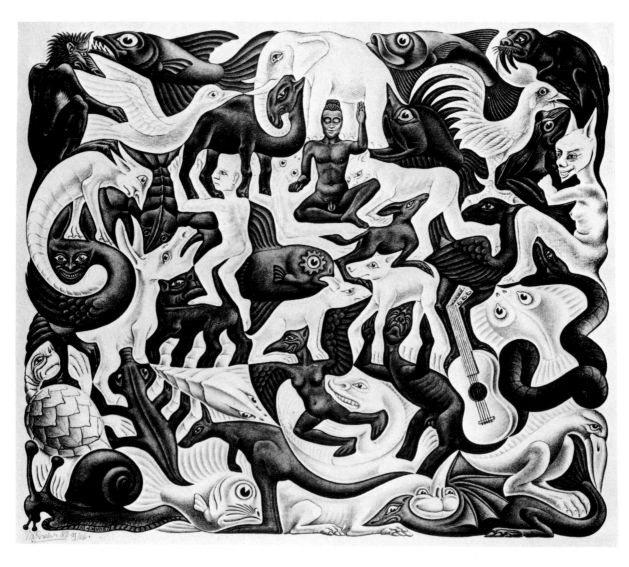

156. Mosaic II. 1957
 Lithograph, 315×372 (12⅜×14⅝″)
 Signed and dated: MCE VII 57

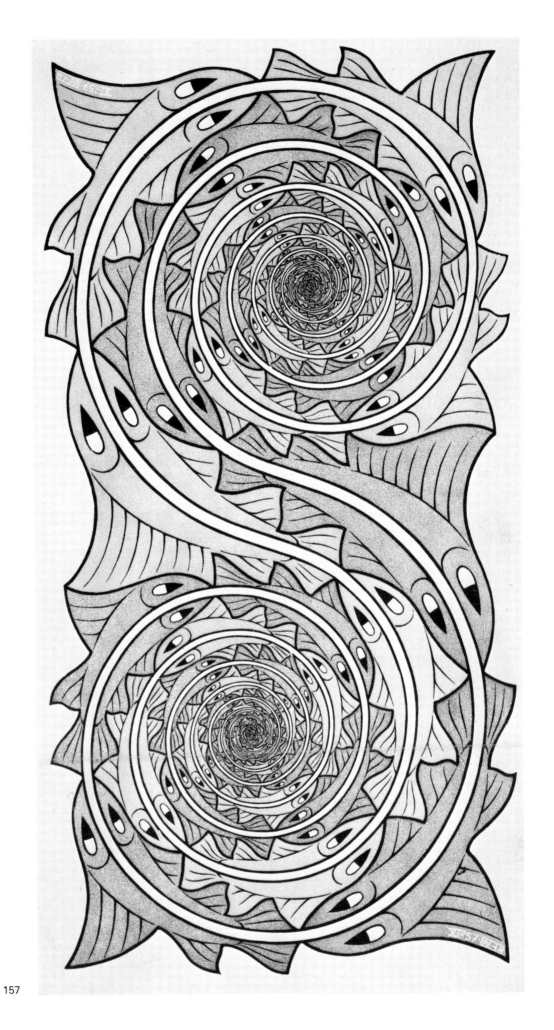

157

157. Whirlpools. 1957
Woodcut in three colors, 447×235 (17⅝×9¼″)
Signed and dated: XI-'57 MCE

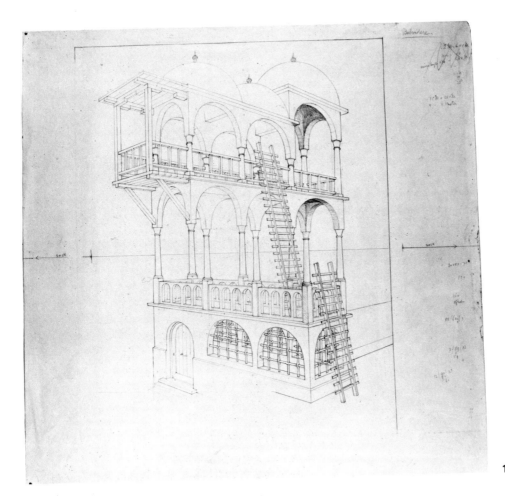

158

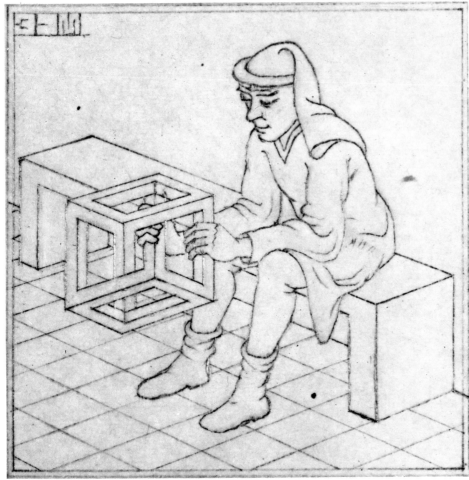

159

158. Study for the lithograph "Belvedere." 1958
 Pencil, 537×552 (21⅛×21¾")

159. Study for the lithograph "Belvedere." 1958
 Pencil, 140×122 (5½×4¾")

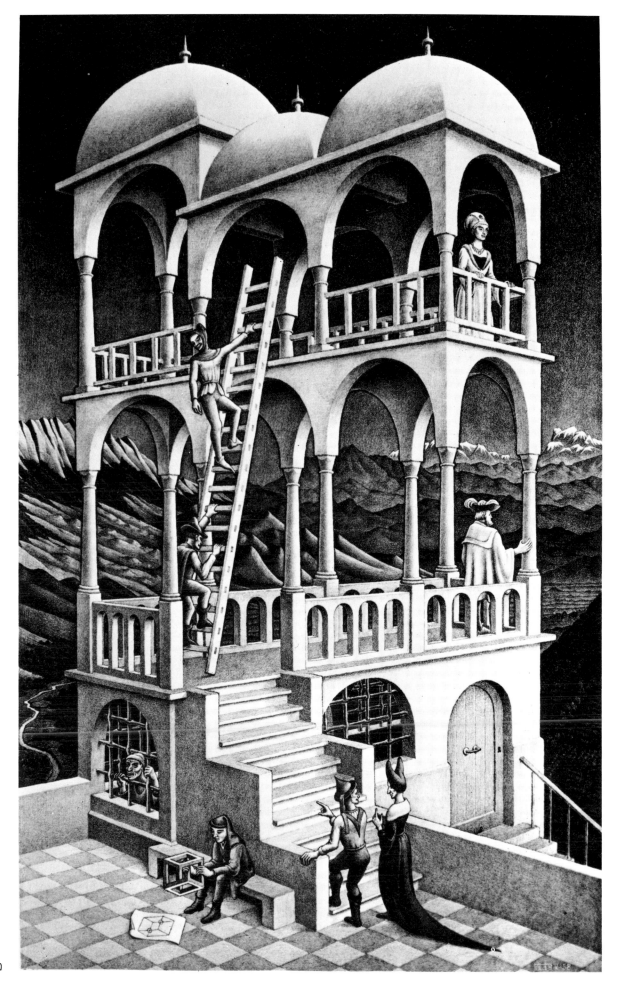

160

160. Belvedere. 1958
Lithograph, 461×295 (18⅛×11⅝")
Signed and dated: MCE V-'58

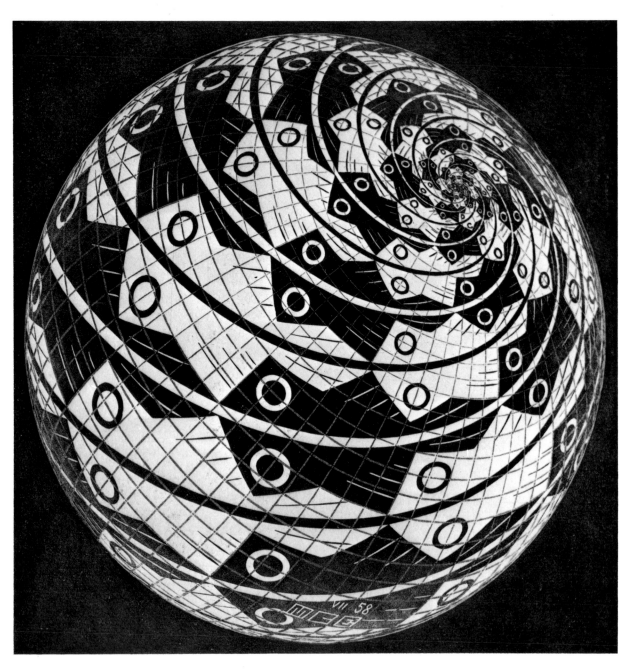

161. Sphere Surface with Fish. 1958
 Woodcut in three colors, 340×340 (13⅜×13⅜″)
 Signed and dated: VII-58 MCE

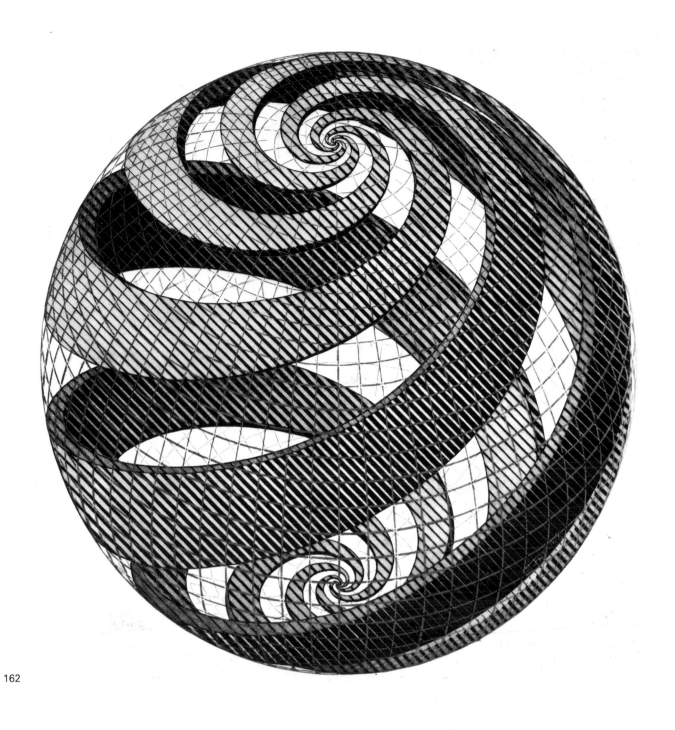

162

162. Sphere Spirals. 1958
 Woodcut in four colors, diameter 320 (12⅝'')
 Signed and dated: MCE X-58

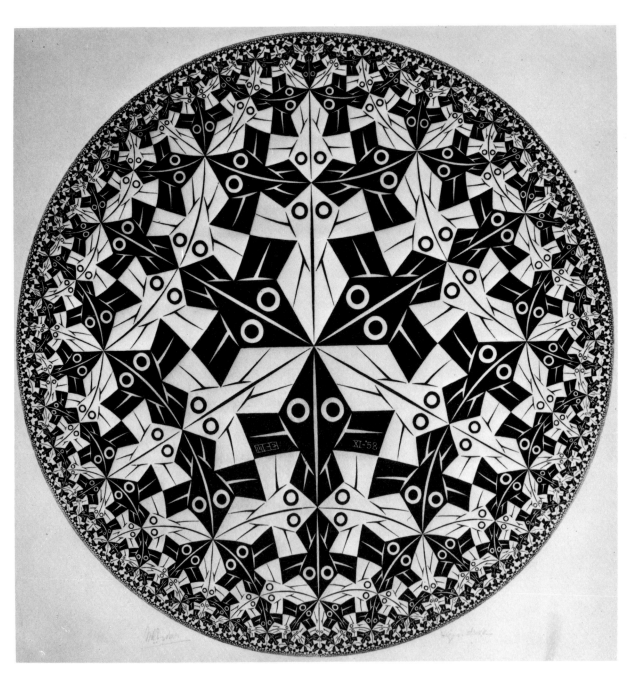

163

163. Circle Limit I. 1958
Woodcut, diameter 418 (16½″)
Signed and dated: MCE XI-'58

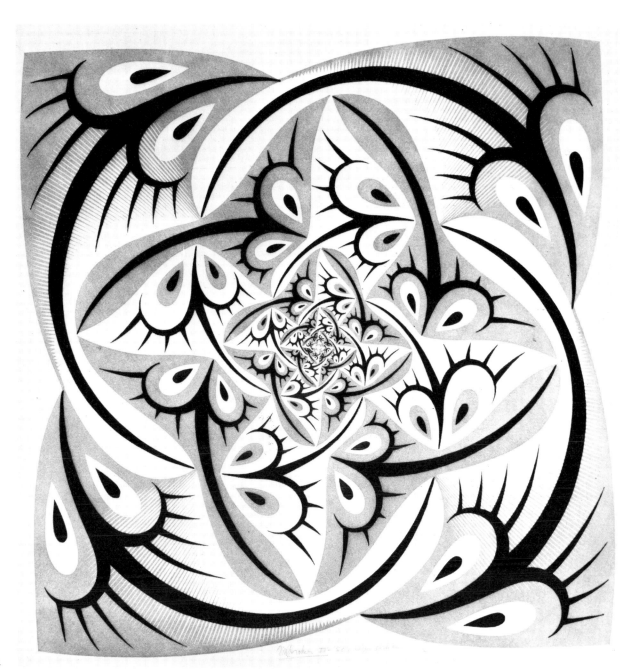

164

164. Path of Life II. 1958
 Woodcut in two colors, 370×370 (14⅝×14⅝")

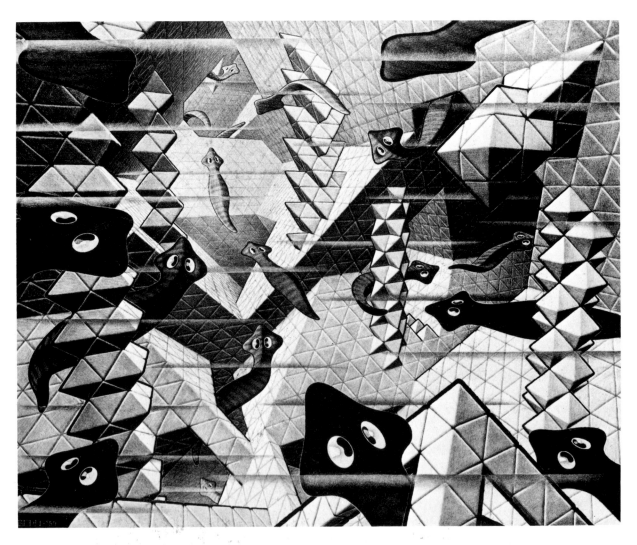

165. Flatworms. 1959
 Lithograph, 338×413 (13¼×16¼")
 Signed and dated: MCE 1-'59

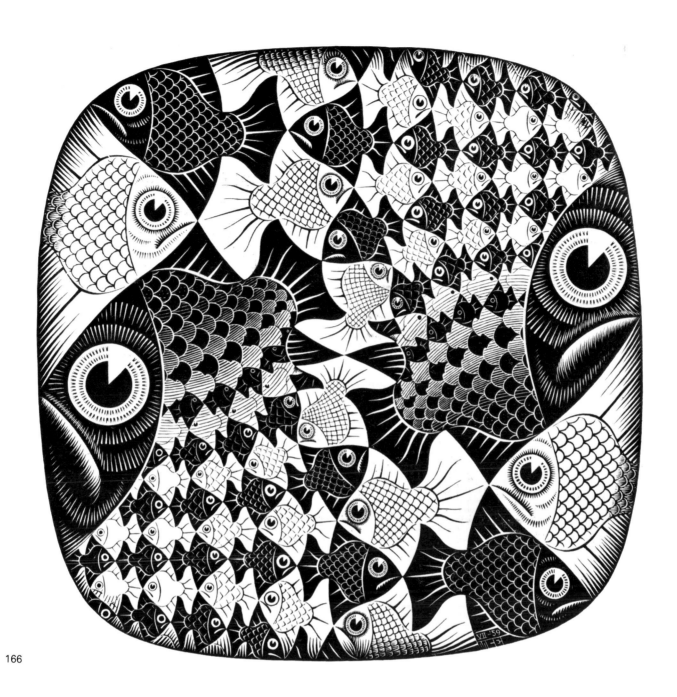

166

166. Fish and Scales. 1959
Woodcut, 380×380 (15×15″)
Signed and dated: VII-'59 MCE

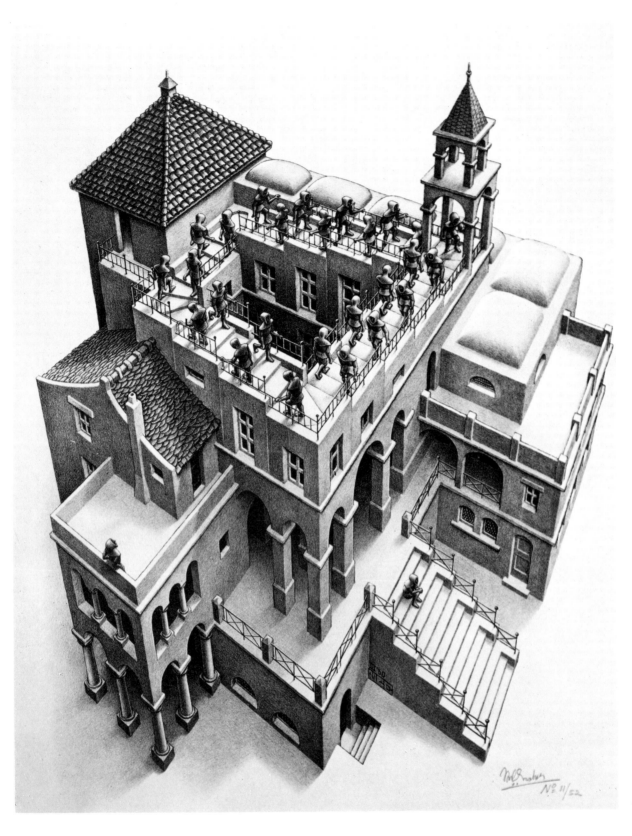

167. Ascending and Descending. 1960
Lithograph, 350×285 (13¾×11¼″)
Signed and dated: III'60 MCE

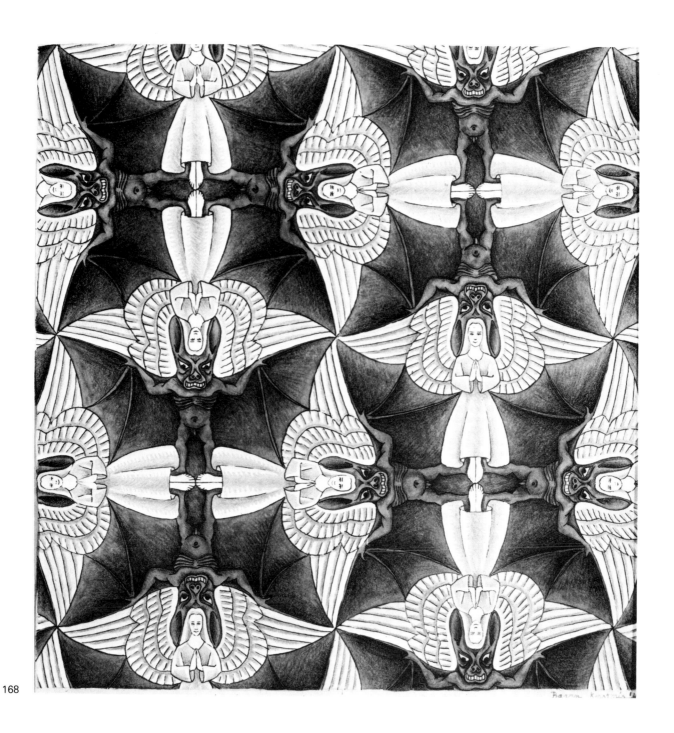

168

168. Study of Regular Division of the Plane with Angels and
Devils. 1941
Pencil, india ink, blue crayon, and gray and white '
gouache, 360×268 (14⅛×10½")
Dated and inscribed: 2 motieven-systeem X E Baarn
Kerstmis '41 (used for the woodcut Circle Limit IV, 1960,
no. 171)

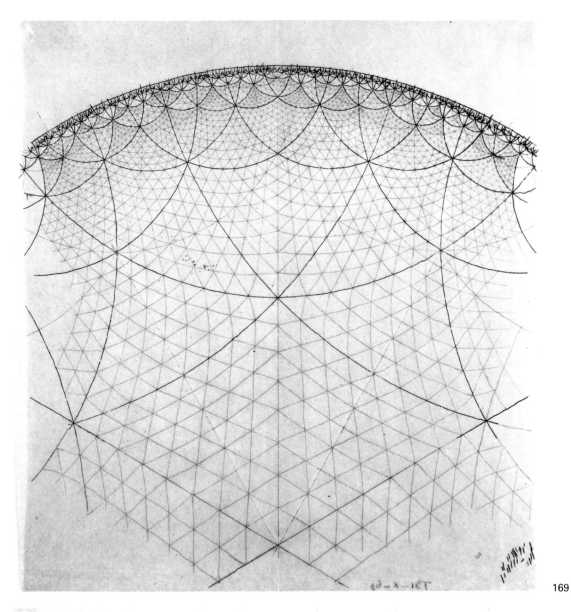

169

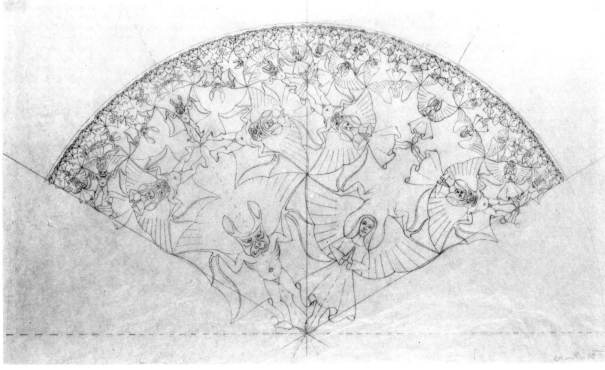

170

169. Study for the woodcut "Circle Limit IV." 1960
 Pencil with india and red ink, 250×235 (9$\frac{7}{8}$×9$\frac{1}{4}$'')

170. Study for the woodcut "Circle Limit IV." 1960
 Pencil, 249×423 (9$\frac{3}{4}$×16$\frac{5}{8}$'')

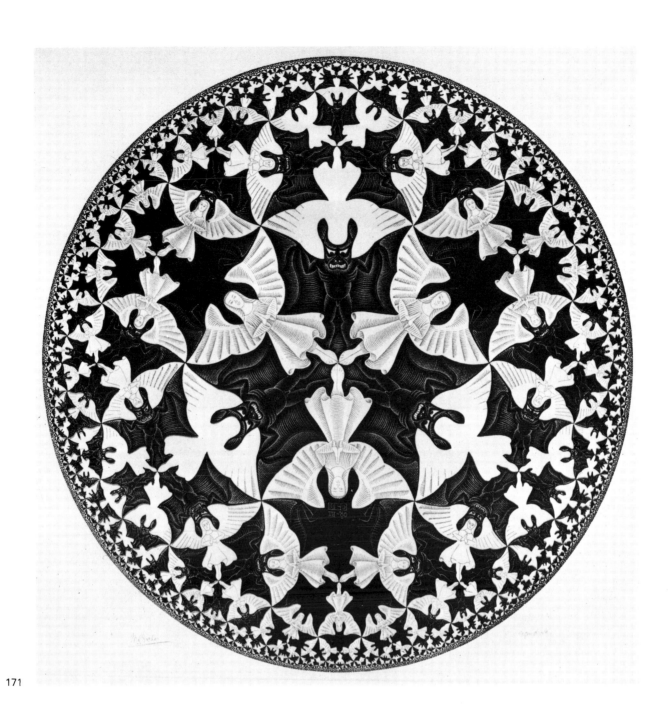

171

171. Circle Limit IV. 1960
 Woodcut in two colors, diameter 417 (16¾'')
 Signed and dated: MCE VII-'60

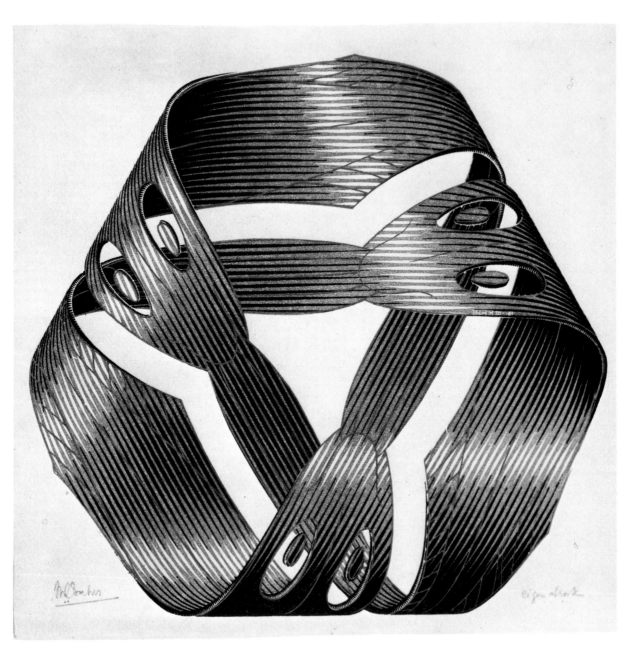

172. Moebius Strip I. 1961
Wood engraving in four colors, 240×260 (9½×10¼″)
Signed and dated: MCE III-'61

173/174

175/176

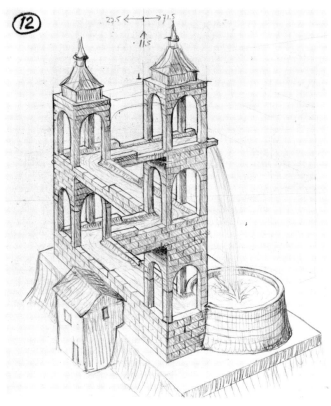

173. Study for the lithograph "Waterfall." 1961
Pencil, 135×170 (5⅜×6⅝") (version of an "impossible triangle," such as published by L.S. and R. Penrose in The British Journal of Psychology, February, 1958)

174. Study for the lithograph "Waterfall." 1961
Pencil, 140×140 (5½×5½")

175. Study for the lithograph "Waterfall." 1961
Pencil, 265×185 (10⅜×7⅜")

176. Study for the lithograph "Waterfall." 1961
Pencil, 208×191 (8¼×7½")

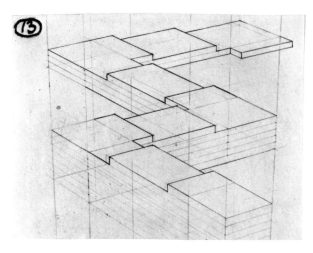

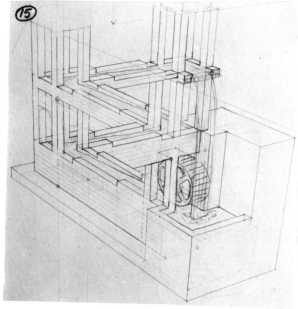

177/178

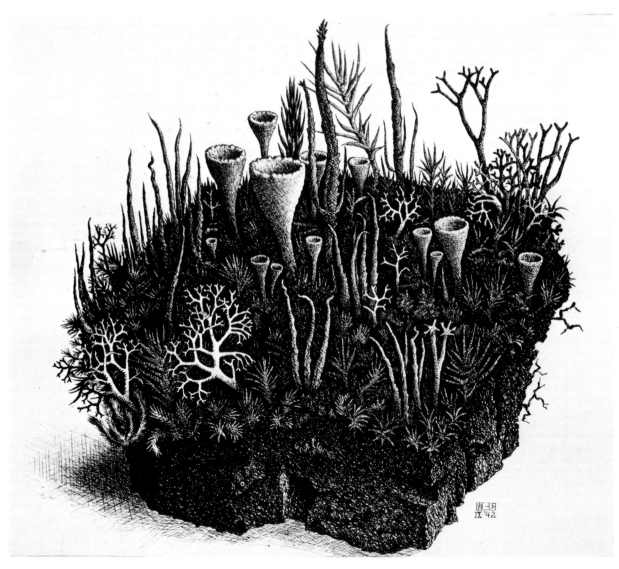

179

177. Study for the lithograph "Waterfall." 1961
Pencil, 85 x 114 (3⅜ x 4½")

178. Study for the lithograph "Waterfall." 1961
Pencil, 175 x 175 (6⅞ x 6⅞")

179. Study of Plants. 1942
India ink, 202 x 237 (8 x 9⅜") (used for the lithograph
Waterfall, 1961, no. 180)

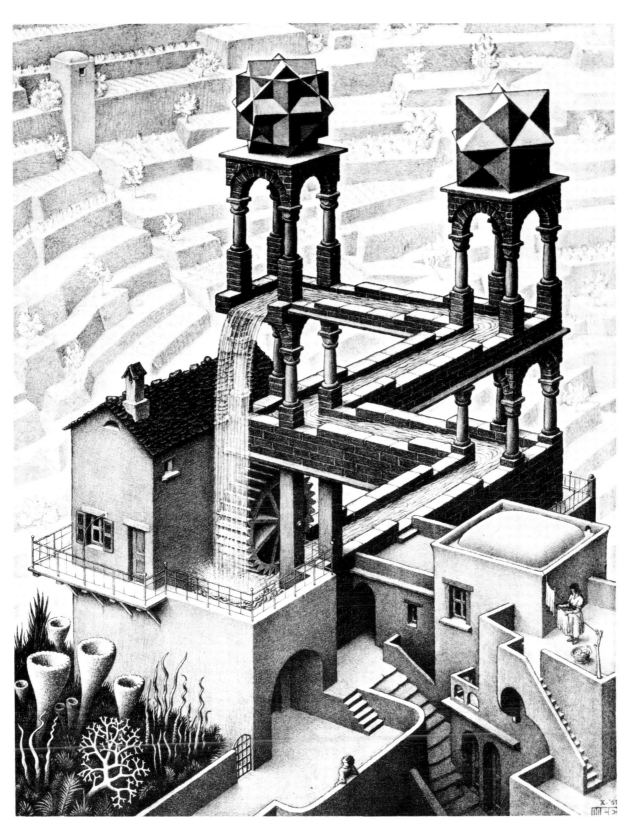

180

180. Waterfall. 1961
Lithograph, 378×300 (14$\frac{7}{8}$×11$\frac{3}{4}$″)
Signed and dated: X-'61 MCE

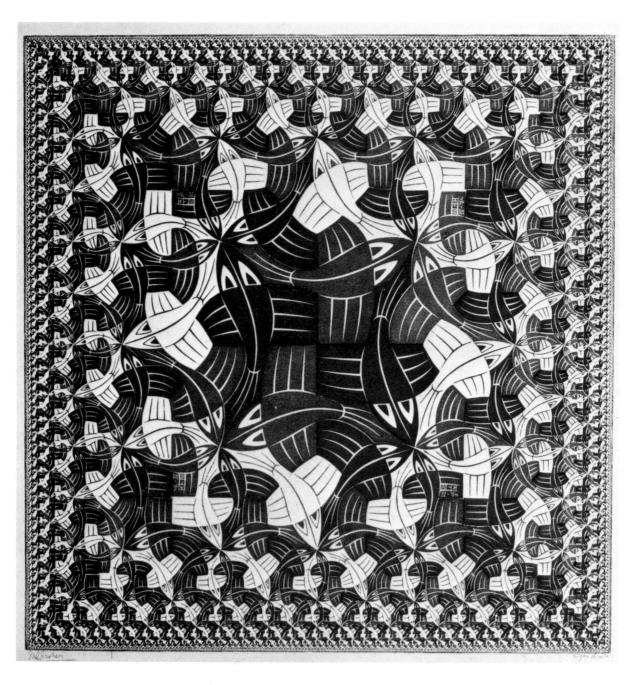

181. Square Limit. 1964
 Woodcut in two colors, 340×340 (13⅜×13⅜")
 Signed and dated: MCE IV-'64

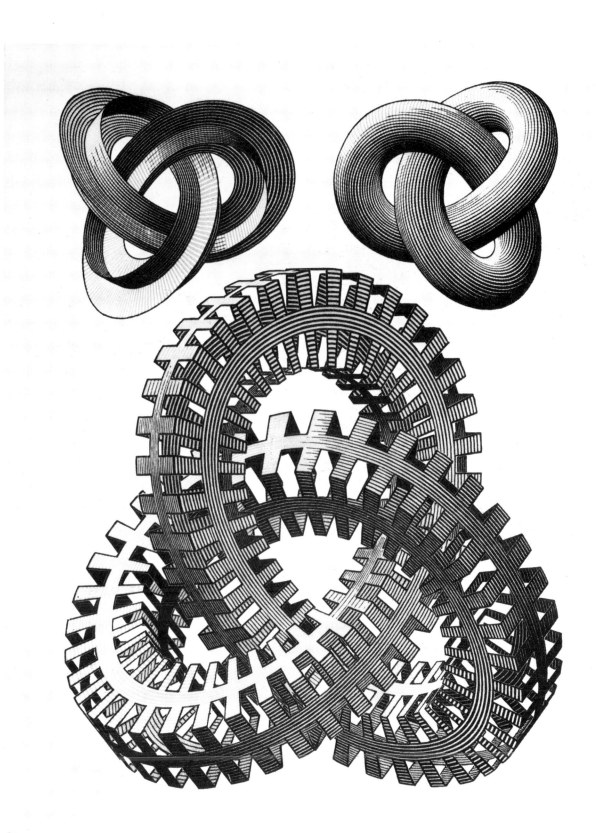

182

182. Knots. 1965
Woodcut in three colors, 430×320 (16$\frac{7}{8}$×12$\frac{5}{8}$″)
Signed and dated: MCE VIII-65

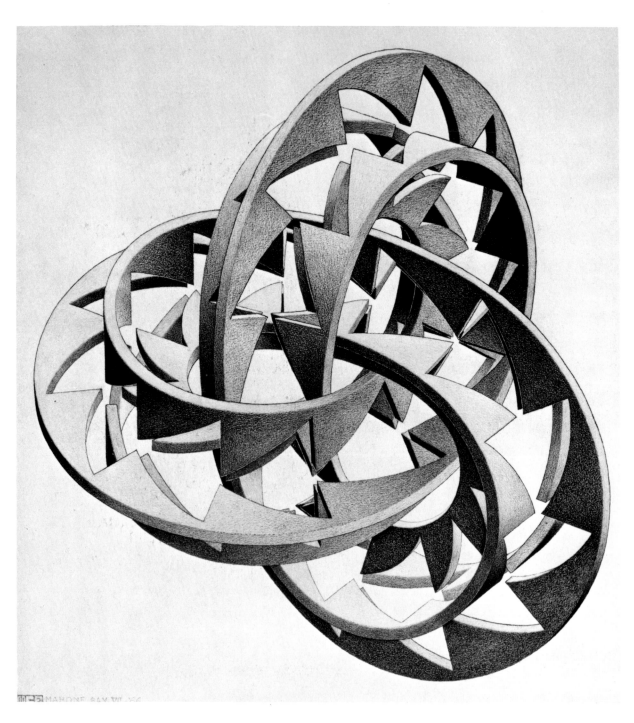

183

183. Knots. 1966
 Pencil and black crayon, 371×341 (14⅝×13⅜'')
 Signed, dated, and inscribed: MCE MAHONE BAY VII-'66

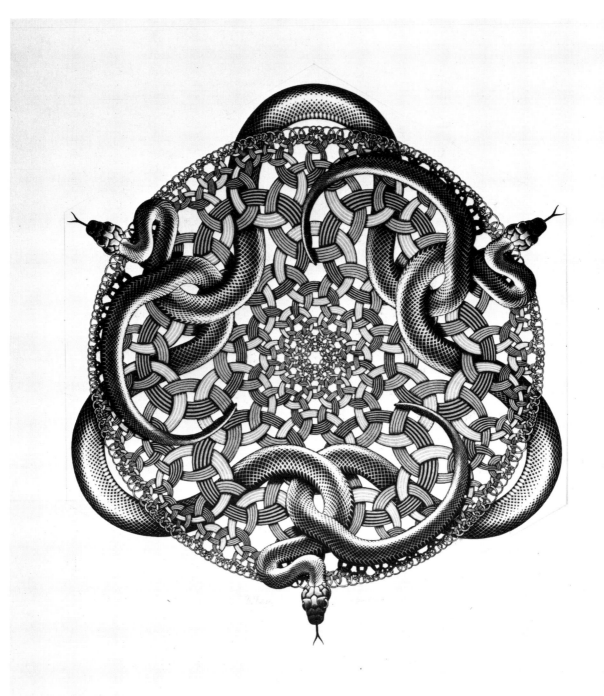

184

184. Snakes. 1969
 Woodcut in three colors, 500×445 (19⅝×17½")